Praise for

POLLAK'S ARM

"This enthralling novel describes an undying passion for antiquity with an underlying theme of great poignancy. A great read."

—PHILIPPE DE MONTEBELLO,
former director of the Metropolitan Museum of Art

"This intense and exciting book brings back to life the voice of Ludwig Pollak who, when confronted with Nazi-occupied Rome's grim reality, powerfully conveys a taste for collecting, the pleasure of erudition, and an unshakeable faith in culture. This period of European history—remarkably captured here by Hans von Trotha—still has much to tell us."

—SALVATORE SETTIS,
chairman of the Louvre Museum Scientific Council
and author of *Laocoön* and *If Venice Dies*

"Hans von Trotha has composed a small jewel of a novel. Set as the Holocaust reaches Rome in October 1943, it quietly evokes an archaeologist's reflections on a European life of scholarship and art. The result is physical death for him and his family. Yet this book offers vivid testimony of his words and actions in defense of humane culture against barbarism."

—R. J. B. BOSWORTH,
author of *Mussolini* and *The Oxford Handbook of Fascism*

POLLAK'S ARM

Hans von Trotha

TRANSLATED FROM THE GERMAN BY
ELISABETH LAUFFER

NEW VESSEL PRESS
NEW YORK

 New Vessel Press

www.newvesselpress.com
First published in German as *Pollaks Arm*
Copyright © 2021 Verlag Klaus Wagenbach, Berlin
Translation copyright © 2022 Elisabeth Lauffer
The translation of this work was supported by a grant from the Goethe-Institut.

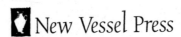

Library of Congress Cataloging-in-Publication Data
von Trotha, Hans
[Pollaks Arm, English]
Pollak's Arm/Hans von Trotha; translation by Elisabeth Lauffer.
p. cm.
ISBN 978-1-954404-00-7
Library of Congress Control Number 2021940448
1. Germany–Fiction

Cover image credits:
Laocoön illustration: iStock/duncan1890
Exterior of Saint Peter's Basilica: Engraving by Etienne DuPérac,
The Metropolitan Museum of Art
Snake: Amphibies XI, The New York Public Library Digital Collections
Photo of *Laocoön and his Sons* by Livio Andronico

The Laocoön sculpture group as restored with the bent right arm discovered by Ludwig Pollak.

IF THE WEATHER conditions had been better—

That wouldn't have changed a thing.

You're right, of course. An SS captain doesn't take his cues from the weather.

The weather is more likely to take its cues from the SS.

Wasn't the same once said of Goethe?

Almost certainly.

Perhaps you'd prefer to write it all down? If so I'll leave you to it. The room is yours to use as long as you'd like. No one will disturb you. Time is one thing we have in abundance here in the Vatican.

A small room on the ground floor, where little sunlight reaches the large double window. A modern desk lamp with a black metal shade casts its light on the keyboard of a bulky typewriter; along the top of the carriage, *Remington* stands in peeling gold lettering. It holds a blank sheet of paper.

K. sits at the typewriter, Monsignor F. facing him, late on the afternoon of October 17, 1943. K., a secondary school

teacher from Berlin stranded in occupied Rome and harbored in the Vatican, has come to this austere vestibule in a building near the German cemetery Campo Santo Teutonico at the request of Monsignor F., a retired prelate and ecclesiastical diplomat whose German is flawless, virtually accentless except for a trace of Italian inflection. K., wiry and wan, seems tense. He looks tired. His blue eyes are opened wide, disproportionately large in his narrow face with its taut, pale skin. The monsignor asks K. if he would prefer to tell him his story or write it down. He would rather tell him, K. responds, but isn't sure he can, doesn't know where to start.

Giving a personal account. That was something Pollak kept repeating. That we all have a duty to give a personal account. He kept stressing the importance of telling our own stories, passing them on. That was why he wouldn't let me leave. That was my chance, K. says. I don't know why Dreyfus, of all people, comes to mind, he continues without pause. The Dreyfus Affair. Perhaps it's because, at his own mention of Dreyfus, Pollak began to divulge the details of his diary. Or perhaps because I had never considered how an act as blatantly anti-Semitic as convicting a Jewish artillery officer of treason, when he was so obviously innocent, would not only polarize French society, but serve as a frontal blow to Jews— and thus, liberals—across Europe.

The monsignor nods. I was in Paris at the time, he says. Émile Zola was convicted and forced to leave the country. He denounced the outcome of the trial in an open letter,

stating that the true culprit had been acquitted and outlining how that had happened. The headline read *J'accuse* in big letters.

Pollak once caught sight of Dreyfus here in Rome, K. says. He appeared a broken man to him. It's no wonder. Pollak was standing with his back to the window as he told me about it. Behind him, dusk would soon fall over Rome, I remember thinking, then night. Nights in Rome have been very dark of late.

He clearly remembered writing Dreyfus's name in his diary, Pollak said. Given the evidence, at that point he still assumed Dreyfus would be acquitted. Everyone did. The century is drawing to a dignified close, he wrote in his diary. Terribly histrionic, he said, but that was how he felt back then. July 1, 1899. He could still see himself writing the date in black ink, the one, the eight, the two nines. That's the level of detail Pollak went into. Trial in Rennes, charge of treason brought against Jewish officer Alfred Dreyfus. Who can describe the emotion, he wrote, when justice prevails over perfidy. Then came the verdict in September. Five votes yea, two nay, ten years' imprisonment in light of mitigating factors. It was the first time he ever considered expunging pages from his diary, but there was no blotting out what had occurred, part of which was, of course, one's views at the time. Truth would not triumph—Pollak's words—until much later, in 1906.

That was the year Pollak published his findings on the arm, the monsignor interjects.

Yes, K. affirms. *The Arm of Laocoön.* Brief text, only a few pages long, factual, no frills. No mention of the fact that this arm, of course, changed everything.

There is a pause. The monsignor clearly expects K. to discuss the arm in response to his interjection, but K.'s report is slow in getting off the ground.

When you gave me this order—with all due respect, it was an order, not a request—I agreed without a second thought. I couldn't have known I would return from the apartment at Palazzo Odescalchi a changed man. I couldn't have known how trying the visit would become. It changed everything. I never realized how dangerous the situation might be. It never crossed my mind that I might stay as long as I did. Had I considered any of these factors, I wouldn't have gone. I'm not suited for heroics. Whatever a hero is, K. repeats the monsignor's rejoinder. You're right, of course. I suppose there was a reason I failed to make it back to Germany, after all.

The situation in Rome—and with it, in the Vatican—has intensified since Italy surrendered to the Allies on September 8, thus dissolving the country's allegiance to Germany. The Germans now have full control over the city. Saint Peter's has been closed for days, the first time this has happened since September 20, 1870, when Rome was captured by Italian forces in the battle against the French for the Vatican. People are seeking refuge in the Vatican in greater numbers than usual, out of fear of the Germans. Even the king's grandchildren were delivered here without advance notice. In response to the constant threat of

air raids, those turned away instead gather outside Saint Peter's, in the hope that they might find protection in the shadow of the cathedral. The Swiss Guard has been armed with modern weapons since September 9. The few passenger vehicles that leave the Vatican now are quick to return.

You were the first to say it, and after you did, I felt almost ashamed to have thought I'd simply board the train and go home. As it was, I wouldn't have made it all the way. Since the KLV was instituted—ah, forgive me, Germany has been tending toward abbreviations of late. KLV stands for *Kinderlandverschickung*, an initiative to evacuate children and mothers from cities, because of air raids. What it means for us teachers is empty schools. It means I'm not return-ing to work back home in Berlin; they're expecting me in the countryside of southern Germany. It's not far from here. That, too, led me to believe it might work. I've heard that the northbound tracks are in remarkably good shape. Seems they're being put to use. Besides, I had no idea where I might stay, where I might feel safe. Or as safe as anyone might feel in Rome these days. I am eternally grateful to you for the room you have provided me here in the Vatican. We're safe here. Aren't we? Makes it seem all the more hare-brained to have stayed with Pollak as long as I did. Hare-brained, yet the most important thing I have ever done.

The monsignor, once a tall man but now slightly stooped, the robustness of his presence nevertheless unchanged, sits in

an armchair by a dark wooden desk that has clearly been a fixture in the room for a long time, with his back to the door. The teacher is seated opposite him in a similar, if not identical chair, between them the Remington. A flat, rectangular parcel wrapped in brown paper—what appears to be a picture frame—lies by the typewriter alongside an old leather cup containing a few writing implements and office sundries. A pile of thin sheets of blank paper peeks out from underneath. What, K. asks, is that wooden structure they built on the white line in Saint Peter's Square? Is it cause for concern?

The monsignor assures K. that the building in question is a shelter for German soldiers, who since September 13 have been posted at the dividing line that Vatican staff painted on the cobblestones. Even Germans were not allowed to cross this line. And even German soldiers, the monsignor noted, were people.

It just occurred to me that I haven't slept properly this entire time, K. says. I can finally sleep again, now that I'm waking up in the Vatican. Rome is so eerie these days. The city seems caught in the chokehold of some immense, capricious beast, especially at night. Pollak said the same thing, worded a little differently, but similar. A monster lying in wait, outwardly quiet, but ready to strike at any moment. Every monster strikes eventually. It's in its nature. Those of us harbored here in the Vatican feel a wave of gratitude and relief whenever we reach a building that the German embassy has marked as Vatican property. It's like a magic spell keeping the monster at bay. One may feel safe here.

He has always been a closed book to me. Formidable. An extraordinary human being, you might say. There's an aloofness to him too, though, an assiduous dignity in everything he does and says. I always felt slightly intimidated by Pollak. Meanwhile, and I scarcely need to tell you this, he is kindness incarnate. Usually, that is. At times he can be caustic, cutting. He chooses his words with special care in those moments. He has always concerned himself with language, that melodic German of his, fetching and warm with a faint quaver that recalls old Austria and Prague and, for a long time now, even Rome.

Perhaps it is the myth itself that is so intimidating. The myth of Ludwig Pollak. An aura like that weighs not only on the man, but on those around him. I've only encountered him on a handful of occasions, and even those were a while ago. I was trying to remember on the drive to Piazza dei Santi Apostoli. I'm quite good at recalling the past. It comes with the territory; it's incumbent on me as a teacher to present things such that others can make sense of them. During the car ride, I realized just how few encounters it had been. I didn't know much about Pollak. I was aware of his ties to the Vatican, because of the arm. The arm wasn't the only reason, though. I know that now.

The monsignor listens attentively, his fingertips lightly pressed together. From time to time, without changing this posture, he sets his elbows on the tabletop and touches his chin to his index fingers, the tips of his middle fingers resting

on his lips. Only occasionally does he break his silence with a quick question or comment.

He's shorter than I remembered, and bald, says K. He's done away with his beard but kept the mustache. When I first arrived, I didn't know what to say. I felt outside myself, as if I were merely observing the scene, rather than participating in it. The two gentlemen were still there at that point. Yes, they were there by the time I reached Palazzo Odescalchi. One of them left straightaway. Seemed to be in a hurry. Is that important? His name started with *M*, two syllables. Mohren, or something like that. Maybe Mohnen. The second gentleman was Professor Volbach. You don't know Volbach? Professor Wolfgang Fritz Volbach. He, too, has been provided refuge here in the Vatican, for the last ten years now. As far as I could gather, Professor Volbach had received his information from the other man—that is, the man who left the moment I arrived. They did not seem to have come together, though, nor did they leave together. Mohnen. Yes, that's right. I'm almost certain that was his name.

Wilhelm Mohnen, the monsignor interjects. We can't quite make sense of the fellow. He works for the German embassy in Rome, but in Paris, too, apparently. It doesn't seem entirely aboveboard, but no one knows for certain. Art sales are his métier. He knows his way around that world, and his services are highly sought-after, though I couldn't say by whom. He is therefore well aware of who Ludwig Pollak is.

That must have prompted him to inform Professor Volbach, then head to Palazzo Odescalchi himself.

Mohnen looked at me but barely saw me, K. says. As he left the apartment, he said, *This, sir, is the last we'll ever see of each other.* Professor Volbach didn't stay long, either. I happen upon him in the Vatican with some frequency, and saw him at the museum in Berlin once or twice. He worked at the Kaiser Friedrich Museum. They booted him out in '33. His mother is a Jew, though he's more Catholic than I. Volbach told me that his mother's family had converted to Protestantism, starting with her grandfather. She herself later converted, only from Protestantism to Catholicism. How much more Christian can a person get? It was of no use to him, though. He found employment at the Museo Sacro, though I've never asked how. He's been in Rome since '34. It's why I assumed you'd know him, though I realize you have spent a great deal of time abroad.

If I've got my facts straight, Volbach is responsible for the catalogues at Museo Sacro. His enthusiasm for catalogues, it occurs to me, is what connects him to Pollak. Volbach once told me about the catalogue he wrote for the Kaiser Friedrich Museum; he was so furious about his termination, he pitched the manuscript into the River Spree. The museum is on an island, after all. He was still livid as he recounted the story. But proud, too.

Volbach was visibly perturbed, seemed—how should I put it—frantic. I later understood why. They hadn't sat down, which suggests that the two gentlemen hadn't been

at Palazzo Odescalchi long before I came. Professor Volbach was in his coat, holding his hat, turning it round and round. I stood by the door. Volbach shook Pollak's hand and strode from the room, then from the apartment. He gave me a quick nod as he passed. The words the other man had spoken—*This is the last we'll ever see of each other*—still echoed, as if Volbach had repeated them on his way out. I don't think he said anything, though. Then I was alone with Pollak. He had immediately recognized me, at least, and invited me in.

Not knowing how a journey will end, he said, is no reason not to take it.

Perhaps an earlier comment of mine prompted this riposte, or perhaps it was something one of the two men had said before they left. He tacked on his signature *isn't that right*, with emphasis on the *isn't*.

We know how this journey ends, though, I responded. That's why I'm here.

With all due respect, Pollak countered, even the highest authority among those who sent you does not know what the future truly holds. The here and now is not his concern; it is the hereafter, which in my case does not apply. Although—

He didn't finish the sentence.

But, he added, please convey my sincerest thanks to everyone in the Vatican. Yes, he said, I am touched that they sent you.

I exhorted him to hurry and prepare to leave. He didn't react, which I found unnerving. I was certain he would rush to fetch his family and get ready, but he just stood there,

posture erect but weary. It was then I noticed how much he's aged. His presence is awe-inspiring as ever, the way he holds your gaze with those piercing eyes. However, he seems weakened by pain, I myself was pained to see. How old do I reckon he is? Mid-seventies, I'd say. Yes, he must be in his mid-seventies.

Quick, we must leave for the Vatican this instant—you, your wife, your daughter and son. Everything's been taken care of; we just have to go downstairs. The car is waiting.

He closed his eyes. The mention of his family appeared to distress him. They must have been asleep in the adjacent rooms, I assumed, because it was so quiet.

We must hurry, I said after another pause that felt too long. I lowered my voice because of the preceding silence. To reinforce my appeal, I added, we don't know when they're coming.

Or if, he retorted to my surprise. I ignored the comment. I was in no mood to debate the immediacy of the peril he was in—or indeed, the peril we were in, I realized then. I imagined what might happen if I were still in the apartment when marauding SS troops reached the Palazzo Odescalchi address on their list. It was unlikely, that much I knew, but once a thought like that crosses your mind, it lodges there and wanders through your entire body. I told him it could happen any minute. I urged him again, my voice quite loud now, to get ready so we could leave, quick. He would be putting himself and his family at great risk otherwise. And me, I added in a small voice. I don't know if he heard.

Their sleeping makes me happy, he said. We have so few reasons to be awake, you see. They may have fewer reasons even than I. At least I have my memories.

I was still standing by the door. It's a truly magnificent room, when you enter the apartment on the *piano nobile* of the palazzo. Basilica Santi Apostoli across the way, open doorways that allow you to see into the rooms beyond. A little getaway, seemingly modest at first glance but sumptuous in reality, though its elegance is unobtrusive. You've never been there? Was it typically here in the Vatican that you'd see him, then, or at the museum?

From the windows you can see the basilica on the other side of the street, which opens into a square between the church and the palazzo. The closer you look, the more apparent it becomes that everything in the apartment is simply exquisite, down to the last detail. Coffered ceilings grant the rooms a subtle stateliness. As is common in Roman residences, the floors are tiled in varied patterns throughout, which provides a bit of lightness to balance out the weight of the ceilings. It is undeniably the home of a collector. The walls, cupboards, and little tables display objects from his collections. There's a bookcase filled with prized folios. Some pieces were missing, though; I noticed gaps on shelves, spots on the wall where something once hung, dark shadows where something once sat, outlines where something once stood. My eye fell on a finely crafted glass cabinet encircled by portraits of women done in various styles. It was clearly intended for displaying his most treasured finds, but there, too, pieces

were missing. In a corner next to it, an ancient sculpture—in a classic contrapposto pose, its right arm missing—stood on a pedestal. A doorway to the right opened into the neighboring room.

He seemed to notice my looking around, evidently with less discretion than I'd thought.

Please feel free to look, he said. Who knows how much longer we'll be allowed to live here? Then, like a fading echo of his own voice, he said, How much longer we'll be allowed to live?

We no longer receive many visitors, and haven't for some time. People know that I speak my mind, so at some point they stopped coming, for fear they weren't the only ones hearing what I was saying.

It's nice here, he continued. We know that. It's very nice, in fact. One must be thankful. But it pales in comparison to the past. Please pardon my contempt and the ingratitude it betrays, but the disparity is simply too stark. It is nice here, but it does not begin to compare to Palazzo Bacchettoni. This home and Palazzo Odescalchi itself represent what the world can be. Palazzo Bacchettoni, meanwhile, was paradise, whoever your god. We moved there in 1903. Margarete, my first wife, and I. The children were very young. Little Wolfie, our eldest, was born the year before we moved to the palazzo. When he turned ten, I began showing him around Rome. Just after his tenth birthday, we went to San Pietro in Vincoli, near where they discovered the Laocoön Group. I took my son to the church to show him Michelangelo's *Moses*, then

the city. My city. It once was, you know. Angelina was born in Palazzo Bacchettoni.

At the mention of his daughter, Pollak teared up. He did not wipe away his tears, but let them run down his cheeks. He stood there, his back very straight, and cried.

She was born in Palazzo Bacchettoni, he said, his voice barely audible, and died in Palazzo Odescalchi.

I'm sure you heard that one of his daughters, the younger of the two, died a few months ago. She'd long had tuberculosis.

Palazzo Bacchettoni, Pollak went on—it had taken him some time to regain his composure, but bound by propriety, I did not use it as an opportunity for a renewed intervention— Palazzo Bacchettoni was originally called Palazzo Alberoni all' Angelo Custode. What a name, he said, then repeated, all' Angelo Custode.

How badly we need our guardian angels after all, he commented. If only we'd known it back then, but we hadn't needed them yet. Or so we thought. Youth invites such thinking. Danger is but a distant reality, isn't that right? Once you've grown old and, should it come to that, the world has turned on you—the world that was your home, or that you thought was your home—and nothing remains but to watch all that has happened around you as it's happening, that is when you remember your guardian angels. And hope they, too, remember you. In some cases, however, it would seem they simply disappear. Fledging, or falling. Where else could they be?

My *angeli custodi* disappeared ages ago, Pollak continued. It's not something you notice at first; it's only when you call for them and receive no response. Not now, not later, not ever. Indeed, they were routed out, just as we—my family and I—were forced to make way so they could construct nicer rooms for the Senate. 153 Via del Tritone. That was the address. The apartment was beautiful as it was, but then—

He paused for dramatic effect. He does that a lot.

—after having lived there for ten years, we added another room by opening what had been a walled-up door. It was more great hall than room, and it was mine, the most beautiful room of all, to my mind, the ceilings adorned in frescoes by Giovanni Paolo Pannini. It was the first time I'd had a home, since Prague. As a person, but as a collector, too. And as a father. And as a Roman. A Roman collector and his family, in a studio festooned in frescoes. I've known the meaning of happiness ever since—how much, or indeed, how little is needed to feel such happiness. And how fleeting it is. I was allowed to live and work in that space. And I kept a tally. I hosted one hundred eighty-three collectors there. For as long as I live, I will never forget that number. Collectors from around the world, encounters with like-minded people. You understand.

It was not a question.

He refused to believe at first that the entire residential block was set for demolition. The entire block, he still fumed all these years later. Including the palazzo. Demolished. For the

Senate. They ultimately kept my hall intact, Pollak said, and used it in the Senate's new administrative building. What does a room amount to, though, he asked, when divorced from the house it belongs to? I speak from experience, he said. I know how it feels to be someplace you no longer belong, or to no longer be in the place you do belong, because that place has ceased to exist. I know what it's like to be robbed of your foundation walls, how difficult it becomes to stand firm or stand at all, to provide others with protection. It's impossible to imagine; it must be experienced, although best avoided. I wouldn't wish it upon anyone.

Pollak told me he never returned to the site, so he didn't know how it felt to be in the hall now, in its new, alien shell. He didn't want to know, either. Things are influenced by their surroundings far more than many people realize, he said. The hall had been forced to yield, and with it, the angels. He, Pollak, had been forced to yield as well, and with him his family. Thus the ingratitude he expressed with regard to Palazzo Odescalchi. Perfect, he said, is the enemy of the good. Always has been. Isn't that right?

What he told you is not quite accurate, the monsignor interrupts K. The hall was not kept intact, at least not in its entirety. The frescoes were dismantled and installed in one of the chambers of the new building. I was there once on business but did not realize those were the frescoes beneath which Pollak seems to have spent his happiest years.

His tears had long since dried, K. continues, but he seemed ashamed to turn his grief-stricken face toward me.

His voice was surprisingly steady again. His voice can take on a unique sensory authority with its warm, penetrating timbre. He chooses his words carefully. Their impact is important to him. You can hear his delight at crafting an effective turn of phrase. Under other circumstances, I would have enjoyed it myself, but given the reality of our situation, I was baffled, stunned that anyone could launch into such an ill-timed conversation, as though I had stopped by for a chat.

IT SEEMED POLLAK was trying to avoid or ignore my call to alert his family and prepare. He had moved to the window and stood there like a figure seen from behind in a Caspar David Friedrich painting, the fading light of a rainy fall afternoon providing the backdrop. I had clearly failed to convey the urgency of my mission. Either that, or he chose not to acknowledge it. I didn't know what to do. When I set out for Palazzo Odescalchi, it never crossed my mind that our talk might drag on. Danger was at hand. It was obvious. I thought it must be obvious to him, too.

Is that the car? he asked. The driver just got out. He's coming inside. He's in uniform. SS.

Those words revealed Pollak's fright at what he saw, but even so, his response was far more muted than seemed appropriate to me. Nevertheless, I felt a momentary hope that the shock might remind him of what was happening and bring him to his senses. I informed him of our cover, assured him that the uniform was no cause for concern, that the driver was loyal—to us, that is. I went to the other window and watched the driver below. He approached the

building, then disappeared through the tall gate between the pillars of the baroque façade. The vehicle looked abandoned on the street. A moment later there was a knock on the door to Pollak's apartment. Though we knew who it was, we both jumped.

Shall I get it? I asked him. I walked down the corridor and opened the door. The driver whispered that he could not wait on the street much longer, or at all, once the sun set. He gave me an address a few doors down and around the corner. He would wait there in the courtyard. He, too, implored us to hurry.

Doctors, midwives, and priests are exempt from the nightly curfew, I said to Pollak as I returned. I am none of those things. For that reason, we have to hide the car. And we have to hurry. At whatever cost, we must make it to the Vatican before nightfall.

Pollak appeared indifferent to the conversation I had had with the driver. He was more interested in the make of the car.

He was still standing by the window. He must have seen the driver leave the house, climb back into the car, turn around, and drive up the street.

I don't know, I said. I'm not sure. Mercedes?

Strauss had the same one, Pollak said. The very same one. Could that be? Or was that too long ago?

Strauss? I asked. He interpreted my involuntary response as an invitation to continue his story.

I have guided many, many people—hundreds, easily—through the collections of Rome, the major private

collections in particular. No one has ever known them as well as I. People knew that in Europe, but not just in Europe.

Please, have a seat, he said for the first time, gesturing toward the bookcase and a table with armchairs positioned at either end. I politely declined and stood demonstratively near the door. He did not sit down, either, but remained where he was by the window. Then he told me about J. P. Morgan.

J.— P.— M.— He spelled it in English before pronouncing the full name in exultation: John Pierpont Morgan. His Majesty, the Dollar King, Pollak called him, then said he had been pleasantly disappointed by the encounter. He enjoys lobbing little barbs like that.

Morgan had gathered parts of his collection in London, missing the chance by a hair to ship the lot to New York aboard the *Titanic*. He always came to Rome in spring, often by way of Egypt, where he wintered. News of his upcoming arrival spread across Europe like wildfire, prompting the continent's major antiques dealers to set out for Rome. A second-story suite at the Grand Hotel was always reserved for Morgan. He tended to stay for several weeks, before continuing on to Paris or London.

Pollak had settled into storytelling now, his bearing unruffled despite the situation.

Morgan enjoyed the company of foreign diplomats living in Rome. The Austro-Hungarian embassy counselor Count Pálffy told him about Russian ambassador Alexander Nelidov's collection and the accompanying catalogue I had written. My first major catalogue. Far more extensive

knowledge is required to compile such a catalogue than most realize. One must be versed in all areas of archaeology, not merely in theory, but in practice as well. Most scholars installed at the lectern, as lionized as they are, would be unable to distinguish an authentic piece from a forgery and don't know the first thing about practice. Those bigwigs are more than happy to use my catalogues, of course, ideally without citing them. They're just catalogues, after all.

When Pollak gets to talking about catalogues, there's a spark that must have been a blazing fire in his younger years. The catalogue is his calling. It's his medium, his way of leaving a tangible legacy of answers, not just questions. Perhaps it expresses his desire to impose order on the bewildering world around us; the narrower context provided by an art collection allows us to examine that world and convert it into a system, a unified whole accessible to all. The catalogue may serve to demonstrate that order or harmony, even completeness is possible. As far as Pollak is concerned, both building a collection and cataloguing it are forms of art.

Bigwig academics, Pollak went on, would sooner grind out an eleventh volume on Phidias or Praxiteles, lifting their material from the existing ten, so all that's new is the title. A catalogue is different. A catalogue represents real research, something new and distinct. It requires great patience, extensive knowledge, and a real love of the object. Over the years I have catalogued many collections, several of them major. That was how I made a name for myself. That was the beginning.

Alexander Nelidov came to Rome as the new ambassador shortly before the turn of the century. Few knew of the precious treasure tucked inside his many trunks and cases. It was I whom he allowed to examine this treasure, record and appraise its contents. Although I was still an unknown quantity, I had the honor of assembling the individual pieces and assigning each its place, these many marvelous, distinct artworks thus giving rise to a new artwork altogether—a collection. Nelidov was delighted. I went on to guide hundreds of guests through the collection. The ambassador wanted me to publish, but that was tricky. Those were the days before the first handbooks on antique gold jewelry became available, and we were missing the provenances of most pieces. For this to be a serious publication, I told him it was imperative that a trip be arranged to eastern Greece and beyond, where the collection's central objects had originated. The ambassador and his Austro-Hungarian colleague immediately secured the letters of introduction needed for such a journey. I set out with a thick stack of these letters and traveled for nearly three months in the spring of 1900. It was the most important trip of my life, and the most beautiful.

Pollak stood by the window and gazed into an imagined distance as he told me about embarking from Bari for Alexandria. What followed were simply catchwords separated by pauses, but uttered with such ardor and emphasis that the images from this voyage in 1900 appeared one after the other like a film, only in color. Orient, he said. Life. Every corner, every turban, every soiled figure an intriguing

picture. Grand luxury in homes. He recounted climbing the pyramids, riding the train for twenty-six hours to Luxor, seeing Karnak, Edfu, Aswan, Memphis, Palestine, Haifa, Beirut, Damascus. He arrived in the most important city for his studies, Constantinople, in May of 1900. It seemed he didn't know what to say—an uncommon occurrence—to describe the impression the ancient metropolis made on him. Overwhelming, he finally stated, before resuming his tale of the Nelidov catalogue.

I worked on it for two years. The book was a real luxury item. I was thirty-four years old, and my name appeared on the cover, directly beside that of the venerable collector. That, too, was overwhelming. It earned me a private audience with the king, who paged through the book, from cover to cover, in my presence. I was invited to the royal ball and made an honorary member of the German Archaeological Institute. The newest honorary member, a Jew. Can you imagine? I had already been dubbed by the Vatican a Commander of the Order of Saint Gregory the Great, because of the arm. Then to read in the newspaper that I, Ludwig Pollak, an Austrian independent scholar in Rome, had been conferred the title of Imperial Advisor by the emperor in Vienna. I went weak in the knees. I had to sit down; I was trembling from head to foot. I barely slept a wink that night, I was so happy. I reflected on the past and future, on the privation and adversity I had experienced, and on the fact that those things were now over. I traveled to Vienna for an audience with the emperor. His face radiated benevolence. I will never forget his smile.

He stood tall against a gray backdrop of waning light, his form framed by the window. Traces of a distant yet immense joy stole over a face that now appeared worn.

Pollak's mind lingered in the Vienna of yore. Outside the Hofburg, a swarm of people had gathered to ogle—Pollak's word—those who'd had an audience as they exited the palace. He had arrived on foot and left the same way, sneaking happily through the crowd.

Should I have summoned him back at that point?

Nelidov died in Paris, Pollak continued. On his recommendation, the tsar had named me a member of the Order of Saint Stanislaus, third class. First the pope, then the king, then the emperor, then the tsar. I was spoiled during that time, a time when Jews were still given medals. Isn't that right? To every thing there is a season, it would seem.

Nelidov's son Dimitri later came to Rome and invited me to Saint Petersburg. The Duma was considering purchasing the collection. I was meant to explain it to the assembly and outline how the individual pieces fit together and describe what an artistic feat the late Nelidov had accomplished by bringing these particular pieces together in this particular way. Certainly no one could have done so better than I, but then came the war, and I was unable to make the trip. After the war, I discovered by chance that the Soviet government was selling pieces of the Nelidov collection in a Sotheby's catalogue. Individual pieces. The news cut me to the quick. You simply don't do that. The collection was auctioned off, scattered to the four winds. All that work, all that time, zeal,

love, and for what? The catalogue was all that remained. It still is.

J. P. Morgan coveted a copy, so he sent me an invitation for a meeting by way of Count Pálffy. The antechamber was full. There is no end to the psychological studies one could conduct on the subject of human flaws in that space; the full range was on display. An odious sight, really, the way otherwise pompous men fawned over Morgan's butler, an uneducated fellow whose salutation they would not have deigned to return in a different setting. Morgan had instructed him to let me through directly, much to the consternation of those who had been waiting. He sat in a palatial room smoking a cigar—a dapper, if corpulent, gray-haired gent with a ruddy face and bulbous nose. He greeted me warmly and immediately asked for the book. I told him it was my pleasure to present him with the last remaining copy. Morgan insisted I include an inscription, which was quite flattering, truth be told. He promised to return the favor with a gift of his own. I had forgotten all about his promise when, months later, a large crate arrived from New York. It contained several magnificent volumes, the publication of J. P. Morgan's antique glass collection.

Pollak's gaze drifted toward the bookcase. In the late afternoon light, the room was like the indistinct background of a nineteenth-century scholar's portrait, the sage elder surrounded by his trusted volumes. Pollak crossed the room and carefully drew a large, elaborately bound book from the shelf with both hands. He placed it on the table, clearly positioned by the shelves for that very purpose.

Pollak didn't wave me over, nor did he open the book, which I suspected was one of those from New York; instead, he stroked the cover almost tenderly, as if to demonstrate his enduring reverence for the familiar old work.

Morgan commissioned leading experts to catalogue his collections, Pollak continued. He engaged Wilhelm von Bode in Berlin, for instance, to publish his collection of Renaissance bronzes, a two-volume work that at the time was the absolute pinnacle of art reproduction, marveled at far and wide. And Morgan remunerated his authors handsomely. Without any prior discussion, he sent Bode a check for more than fifty thousand. Bode directly transferred the sum to the Kaiser Friedrich Museum.

Bode, Pollak repeated. During his tenure as general director of museums in Berlin, when those institutes experienced their resurgence, our ongoing exchange was important to me as an art seller and expert, of course, but also as a person. We toured Naples together in what must have been 1910. There was nothing I could have shown him; a lion like Wilhelm von Bode did the showing. One learned more in two hours at a museum with Bode than in a year's worth of reading.

Bode disliked Rome, preferring Florence. He kept visits to Rome brief and relied almost exclusively on my services when he came. During the twenties, I was a frequent guest of his in Berlin. There the tables were turned, as he was the one making introductions. To collectors I would then guide around Rome whenever they visited.

Pollak kept talking and talking. One association followed the other, tumbling dominoes of reminiscence. How could I have stopped him?

The construction of his museum, the Kaiser Friedrich Museum, was always on Bode's mind. It made him sick, too. I have hundreds of letters from him. They're in the next room.

I was horrified by the idea that Pollak might fetch the letters. I could scarcely imagine anything more thrilling than to sit with Ludwig Pollak and read his correspondence with Wilhelm von Bode, but not then, not at that moment.

He didn't retrieve them. I don't know what stopped him. He remained standing at the table by the bookcase, studying the magnificent tome. I was still rooted in place by the door.

I met Bode several times myself, K. mentions, interrupting his report. Some called him the Bismarck of Berlin museums. When it came to art, Berlin never could hold its own against Paris or London or even Rome. Until Bode arrived, that is. It was he who built a collection commensurate with the new capital city of a new nation state. The people were proud of the Reich, proud of the new capital. In my history classes, I used it as an example when explaining to students what goes into founding a nation. When looking to unite a nation, one needs a king, a national hero, and a national museum. Why, we even had an emperor. Deciding on our national hero proved more challenging. People's minds went first to Schiller, then Beethoven, until they realized it could be none other than Goethe. This assertion would have gone

over well with Pollak, whose worship of Goethe is unlike anything I've seen. He kept coming back to Goethe. He truly idolizes him. He considers Goethe a god, an Olympian. Pollak would avow Mount Olympus can be found wherever Goethe is. He is the only national hero Pollak might have considered. When I was instructed to exchange the emperor for the *Führer* in my little history of nation building, I decided to abandon the lesson altogether. I still discuss the museum with my students, though. That is, I will if I ever see them again.

POLLAK TOOK A SEAT, letting his body fall heavily into one of the armchairs by the bookcase. I stayed where I was. Though outwardly calm, I was frantic. There was fear, there was hope, but there was also the allure of Pollak's tales being told in the one place they belonged.

I had tried clearing my throat at first, sighing loudly or gesturing to indicate that this was no time for stories. If he noticed what I was doing, though, he ignored it. Standing by the door felt like an act of defiance. I was determined not to move. I thought—or at least, I hoped—that it would serve as a kind of silent protest to underscore my position, without having to keep repeating my request that he rouse his family and come with me.

There was a discomfiting levity to his storytelling now, a tone I suspect had not been heard inside Palazzo Odescalchi for some time. I noticed that his parlance had changed. As rarely as I saw him, his use of language always stood out. He became more circumspect, more reserved, not in word choice, but in diction and the modulation of his voice. As you know, I listened to him speak for far longer than intended. I

thought it best to allow him to reminisce and thus regain his strength. Sharing these stories clearly made him feel good. And then we would depart.

A number of the collectors he showed around Rome would ask to see the surrounding area as well.

I had never done automobile tours before, Pollak said. Looking back now, what first comes to mind is how often we broke down. Even Richard Strauss's vehicle broke down a lot. The technology simply wasn't as advanced. Isn't that right? I'm certain things are far better today. Technology has a way of improving by leaps and bounds during wartime. That has always been the case. Human fodder has never been in short supply. Those excursions of ours could hardly be considered a tribute to technological progress. As I recall, though, there was something carefree and jolly about them. It was lovely. Lovely weather, too. It's common to think that in hindsight. One tends to think the weather was nicer and people were friendlier when remembering the past, and although it's not true, there is some truth to it. Every memory has its own truth; otherwise it wouldn't exist. The car trouble was simply part of it. Whatever the issue may have been, it always got fixed in the end. Sometimes we had to wait awhile, but it would seem we had the time.

Before the war—the last one, that is—Rome was flooded with visitors in spring, Pollak said. Some were pleasant, others less so, the latter in the majority. There is no rose without a thorn, after all. By then I had long since sworn off hosting

visitors who, during their stay, brim over with amiability, only to leave and behave as if they've never met you—until, mind you, they need something again.

The more time passed, the longer he spoke, the more detail he felt he could add without encountering resistance, the calmer he appeared and the stronger his voice sounded. He was using memories of the past to defer the present. I was swept up in it. The moment he sensed I was about to interrupt one thread, he would start on something new. In a seeming non sequitur he began telling me about Auguste Rodin.

Rodin had come to Rome in the winter of 1914, as a house guest of the renowned collector John Marshall and his wife. He was trying to avoid the imminent occupation of Paris, having endured one siege already, in '70–'71. He came accompanied by the Duchess de Choiseul, a petite but garrulous and rather unattractive older woman, a benevolent tyrant over the old man, as Pollak put it. Pollak kept delivering gibes I could tell he had repeated many times, though probably not in years. He would then give a little snort, punctuating the flow of his account. In the past it might have been a laugh.

At the time, John Marshall lived opposite Palazzo Zuccari, on the top floor of number twenty-five Via Gregoriana. D'Annunzio lived in the same building, which commands a spectacular view of the city. Pollak first met Rodin at a dinner hosted by the Marshalls in honor of the famous sculptor. To Pollak's surprise, sitting there was a jovial, squat—indeed,

one could even say fat—fellow with a fresh face framed by a long white beard. He had warm eyes and didn't behave at all like a bigwig.

Bigwig is a word Pollak uses a lot. It signifies a species he has always wrestled with and rebelled against. Saturated with indignation and profound disdain, the word stands for a power imbalance as inappropriate as it is unacceptable. He had clearly expected bigwiggery from such a personage as Rodin, but much as he had been with J. P. Morgan, found himself pleasantly disappointed.

Rodin struck me as a friendly, if ponderous bourgeois who had escaped into retirement after putting in his time, Pollak recalled. He spoke very little, by the way, and never about art. I happened upon him several days later. It was morning. He stood alone by the Fontana di Trevi, drawing. He did not take his eyes off the fountain. I didn't dare interrupt, but watched from a distance for a long time, observing the vigorous sweep of his hand as he filled the sketchbook.

To my mind, the most important artist in Rome was the Jewish sculptor Max Levi. He had studied at the academy in Berlin and came to Rome on a scholarship from the Michael Beer Foundation. He later returned on his own. His studio was in the Villa Strohl-Fern. Rainer Maria Rilke was in residence at the same time, both utterly reclusive men. Levi was of strikingly delicate build. Rather melancholy by nature. He was a sensitive person and unspeakably humble. A Jew through and through. It was what first attracted me to him. He led a solitary existence, his only companion a mutt he had

found on the street. He loved that dog dearly. Levi lived for his art. He never married and died young in Berlin. I have two works of his: a life-size terra cotta bust of a Ciociarian model who was famous in Rome at the time, and a relief portrait of me in profile, also in terra cotta.

Pollak rose from his chair with some difficulty, but the desire to show me something gave him the energy he needed. He took a few steps to a chest of drawers to the right of the bookcase. Look, he said, his head lowered. I hesitated, but not for long. Not only would it have been rude to stay by the door, it felt inappropriate to the situation. Then again, perhaps it would have been the right thing to do. I don't know. Fear had anchored me in place, but I was now propelled by sympathy for the elderly gentleman, who increasingly felt like an old confidant. Then there was the—how should I describe it—the energetic charge of the moment, an irresistible draw created by his story. I crossed the room and stood with him at the chest of drawers. The relief lay on top in a black square frame, a circle cut out for the work at its center.

There I am, squaring the circle, as I always say, Pollak quipped. I caught sight of that inkling of a smile he sometimes allowed himself. He did not acknowledge that I had relinquished my post by the door. Standing beside him, I was now part of the Pollakian world that until then I'd been viewing from the outside, like a picture. I regretted my move. And I was fascinated.

I studied the relief. I don't know much about these things, but it appeared finely crafted. It touched me the instant I saw

it. The subject was clearly a younger man, his strong chin bearded. There was a beautiful ear and prominent, but by no means large, nose. Even in relief, an art form that produces meaning by insinuation, the terra cotta eye twinkled. I leaned in closer in the low light for a better look at the facial expression. I tried to imagine Max Levi, this sensitive, gentle sculptor I'd never heard of, but whose image Pollak had just painted so lovingly. I could tell Pollak was pleased by my interest in the relief. There was an affinity between us in that moment that hadn't been there before. To my surprise, he abruptly switched topics yet again.

Most people misapprehend the world of artworks in Rome, he said. He invited me to sit. He looked at me. Our eyes met for the first time, the expressions serious on either end. He returned to his armchair and fell back into it. It seemed I had no other option than to take a seat in the chair opposite.

From across the table, he asked if I knew what an antiquarian was. It felt strange to be so close to him all of a sudden. As if a sculpture had come to life. His face looked like the relief I had just admired, his skin the color of terra cotta in the weak light. I was tempted to retort that of course I knew what an antiquarian was, but in a display of magnanimity, he spared me the humiliation.

The word had a different meaning in past centuries than it does today. Into the 1700s, scholars of antiquity were known as antiquarians. The term only came to denote antique dealers in the 1800s. For centuries, this profession was as

quintessentially Italian as lemons or opera. Everyone from major collectors to crowned heads and moneyed individuals retained an antiquarian in Rome, who kept them informed of potential acquisitions. Even *maggiordomi* of patrician households, cardinals' valets, and lesser Vatican administrators got involved as facilitators to earn a little on the side. Many went to dig sites and bought pieces directly from the workers. On Saturday afternoons, Sundays, and holidays, country folk would flock to Rome with their wares and gather at Piazza Montanara, which no longer exists. Those legions of petty dealers and middlemen would buy whatever looked interesting. Small-time shopkeepers in the area would also swoop in. There was, for instance, a saddler who went simply by Sellaio. He ran a dusty little shop near the Temple of Fortuna Virilis. The artworks he sold were all from the *campagna*, brought in by the farmers whose saddles he repaired. He didn't know the first thing about these pieces, but was a keen psychologist and always charged the right price as gauged by the buyer's response to each item.

Pollak then told me about a gem cutter, whose name escapes me. He was important to Pollak, though. He had written the catalogue for the man's estate auction in 1899. In his words, Pollak conceived of the work as a *catalogue raisonné*. Said it was the first of its kind in Italy. Auction catalogues had been a primitive affair until that point, their contents presented pell-mell without any informed classification of the objects. In other countries—France, in particular—auction catalogues had long been considered publications of real

value. His friend Wilhelm Fröhner had seen to that. Fröhner positively shone in the field, as Pollak put it. His phrasing was obviously intended to express special appreciation, or even deference. It was an instance of the enthusiastic, yet tender, admiration Pollak shows for the elderly in particular.

He asked if I had known Wilhelm Fröhner. In fact, I did meet him once. As a young man, I called on him in Paris. He must have been well over eighty by then, but was still quick-witted and curious. I had a question about a French private collection. He was happy to help. After all those years in France, Fröhner's singsong Baden dialect had acquired an especially melodious lilt. He gave a humorous, albeit respectful account of his experience as a reader for the French emperor, before he became a curator at the Louvre. He was most eager, though, to tell me about his time as a young archaeologist, organizing and cataloguing collections for the Grand Duke of Baden. At the time, I wondered at the importance Fröhner ascribed to that catalogue. I understand now, after Pollak's remarks on the subject. It was Fröhner's first. As I learned yesterday, for those who write catalogues, it isn't just another rote task but a vocation fueled by a sense of higher duty. It's a world of its own, and those who belong view it as a uniquely meritorious avenue of scholarship, and one that exists outside academia, at that. A service to scholarship performed by those denied access to the academic ranks. It's the realm of connoisseurs—geniuses in the shadows, concert masters playing second fiddle. A world of secret competition between largely unknown giants.

Pollak's deep connection to Wilhelm Fröhner seems to have been the most important of his friendships. Fröhner was a mentor, fatherly confidant, and role model, esteemed in every regard. They exchanged hundreds of letters. No one received as detailed an account as Fröhner of the troubles Pollak endured and humiliations he suffered, however abject. If you wish to know what it was really like, Pollak said to me, you will have to look into it later. For Fröhner's eighty-eighth birthday, Pollak wrote that were he with him in Paris, he would kiss his estimable hands in true admiration, as Felix Mendelssohn once did those of old Goethe.

Pollak's tone had grown quite chatty. The more details of everyday life he recounted, the more relaxed his expression became; it seemed the stories allowed him to forget. At times even I forgot where we were.

According to Pollak, archaeological finds were safest in the hands of the Jandolo family, a sort of antiquarian dynasty. There were two brothers, Antonio and Alessandro. Antonio, in turn, had two sons, Augusto and Ugo. Augusto was a poet and antiquarian, perhaps more the former than the latter, Pollak reckoned. Augusto dedicated his book *Li busti ar Pincio* to Pollak, and what's more, Pollak persuaded him to write a play about Goethe's time in Rome. *Goethe a Roma* was performed at the Teatro Argentina, a hall Goethe himself had frequented. Pollak translated the piece into German, which made sense, considering it was based largely on stories he had shared with the playwright. The translation even appeared in print.

In '35, Augusto Jandolo published *Le memorie di un antiquario*. Pollak grew earnest upon mention of the title; his face hardened. I cannot recommend it highly enough, he said. A German version of the second edition was published with Paul Zsolnay Press in '39, though significantly abridged, given the political circumstances.

The grief over his friend's censoring his own work was palpable. Grief, not outrage. Pollak pivoted to the other Jandolo brother.

I often assisted Ugo with both purchasing and sales. For instance, he once came across the upper half of a Hellenistic nude statuette of Aphrodite Anadyomene. It was obvious—to me, anyway—that the figure had been crafted in two pieces. Ugo was chagrined to learn that all he had was the top half. A few days later, while calling on another antiquarian, I spotted the base of the sculpture, half concealed under a cloth in the shadowy back room. I bought it on the spot; the pieces fit together perfectly. Scavengers for remnants had probably found the statue whole and split it among themselves. It was nearly intact, the only part missing the raised right arm.

Pleasant memories cannot exist, Pollak stated for no reason I could figure, if the experience itself wasn't pleasant. Or, he asked, can they? He didn't think so; he had written down everything important, or at least, everything that seemed important to him, because who knew what would prove important in the long run? He had never written much, though, just notes, no stories, with only the occasional lengthier description. It was intended only for me, he

said. They were my experiences, after all. I filled every last page, and yet the things I recorded are those I would have remembered anyway. Or do we only remember those things we write down?

THE MEMORY of my family's expulsion from Italy and escape from Rome in 1915 is all too clear, even without a diary. In the months before we were forced to leave Rome, many of our friends fled in fear. As Austrians, we were now the enemy. I found it impossible to leave until doing so felt truly unavoidable. I sensed I would be unhappy in any place that wasn't Rome, so I tried to keep us here. I spent much of my time buried in newspapers, including French and English ones. I assure you my time would have been far better spent blocking out the present moment altogether and reading Goethe. Yes, that's exactly what I should have done then, and exactly what I should do now.

The embassy tipped me off in May of '15. We left in a panic and sighed with relief when we reached Switzerland, where old friends welcomed us warmly at every turn. We felt we'd been reborn, but not for long.

I always had a cheery disposition, though the circumstances of my life were not always conducive. At a certain point, however, circumstances became harder and harder to bear. My father died in '13. The escape from Rome in '15. No

sooner had we fled Italy than Margarete, my first wife and mother of my children, died in Switzerland. I took the children to Vienna. I had no choice but to loathe Vienna. Isn't that right? The funeral was held at the synagogue in Munich. Margarete was later interred at the Old Jewish Cemetery in Prague. For four years, from May '15 through May '19, the children and I were compelled to stay in Vienna. I didn't want it. The children didn't want it. Nor did Vienna want us. One moment you're a famous archaeologist, esteemed scholar, sought-after consultant, and successful dealer in your beloved Rome, the next you're a displaced widower without a job, a single parent missing your beloved wife, missing your beloved collections. As if that weren't enough, I was conscripted. Stationed in a city you hate in a uniform you hate. I will never forget how it felt the first time I left the house in uniform. The emperor's regimentals. Never since have I been as unrecognizable to myself as in that moment.

Every memory of those years in Vienna is dark. As if the sun never shone. I know it's impossible that the sun wouldn't shine for four years. Still, leaden clouds over a perpetually damp, gray city full of sullen, surly men and women. That is the Vienna I remember. There weren't any fascists yet, mind you, but plenty of anti-Semites, far more than here in Rome. We couldn't have known that it would get darker and darker. Or that that was even possible. Back then, people thought it impossible for an hour so dark to grow even darker.

Know'st thou the land where the lemon trees do bloom . . .

I know it sounds presumptuous, but particularly during those years in Vienna, it always felt as if Goethe had written that for me. It was so fitting. It became something of a prayer I repeated to myself as I walked the streets of Vienna when things were especially bad.

Know'st thou the house, its porch with pillars tall?
The rooms do glitter, glitters bright the hall,
All marble statues stand, and look me on . . .

That's me, Pollak said. There is no better way to describe it. I have always found solace in Goethe. Goethe is solace. Solace is found in true grandeur, not in ideas, which orbit around that which is grand but possess no real grandeur of their own. Noble simplicity is one such byword. It provides no real solace because it lacks real grandeur of its own; at most, it expresses a desire for grandeur. Quiet grandeur. Does that even exist? Probably not, although we won't know for certain until the very end.

In '15, the year we were forced to flee, Rome was still full of collectors. And they needed me. Many were diplomats, some from countries that no longer existed by '19. That was how long it took until we were allowed to return. The museums I had procured so many pieces for and that regularly engaged my services—Berlin, Frankfurt, Hamburg, Dresden, Copenhagen—they were in dire straits after the war, unable to make any major purchases due to inflation. I was fifty years old when they allowed me to return, with the

children, but without their mother. Rome was no longer the same city as the one we had been banished from.

From where I sat I could see the window, says K. After my last failed attempt, my plan was to wait for the right moment, until Pollak had gained strength from telling his story and looked me in the eyes, so I could be certain he was both hearing me and perceiving me, which are not the same thing. The alternative would have been to leave. To leave the old man sitting in the drawing room with his unfinished story, to abandon him and his family. That was the last thing I wanted to do.

Terra benedetta. To researchers and collectors, the treasures buried in Roman soil are what make the city *terra benedetta.* Blessed ground. To me, Pollak said, Rome is *terra benedetta* in every way. For as long as I can remember, it has been my *terra benedetta.*

We had a servant while I was growing up in Prague named Matthes. As a young man, he had fought in the war in Italy in '48–'49. Served under Radetzky. Matthes told me about the plains of Lombardy, the cathedral in Milan, the imposing fortress in Verona, the sea lapping at the streets of Venice. I took vicarious pleasure in his memories of Italy's marvels. He awakened my yearning for this country, but it was Goethe who captured it in words. I will never forget the first time I read Goethe's *Italian Journey,* the first of countless times. I know it nearly by heart. I will sometimes conflate my own memories with passages from that singular work.

My second encounter with the country of my dreams was also thanks to our man Matthes. There was a storage depot near our apartment that housed old books from the estate of a canon of the cathedral in Prague. Matthes gave me permission to dig through the books. I found a German guidebook for Rome with steel engravings, a Baedeker from the late forties. Matthes gave it to me as a gift. I was twelve.

Pollak looked up at the bookcase and seemed to hesitate, before standing up with less show of effort than before. On one of the upper shelves, just within reach, the nearly hundred-year-old Baedeker guidebook occupied what was clearly a position of honor. He reached for it with his left hand, bracing himself with his right in a gap between books on a lower shelf. He gazed at the old book, turning the pages with care. It depicts a Rome that has long ceased to exist. I was certain the same thought occurred to him.

Did you know, he asked, probably to banish the thought, that Italy left its mark on Prague as well? It was one result of northern Italy's having belonged to Austria for four hundred years, he said, grasping the Baedeker. I thoroughly investigated this history when I came to Rome.

It was another reason I had always wanted to visit the city. Make my way to Rome with the Baedeker and Goethe. That was the goal. I couldn't have foreseen that Rome would one day become home, a homeland in the truest sense for my family and me. Nor could I have known that Goethe's scion in spirit, Gerhart Hauptmann, not to mention Richard Strauss and all the others, would come looking

for me, for Ludwig Pollak, to show them around Rome, my Rome.

My father, you must understand, was the only child of a simple linen merchant from Humpoletz, near Deutschbrod southwest of Prague, where there was a small Jewish community. He struggled to sustain his family by peddling goods in nearby villages. I never knew my father's parents. Family lore had it that a relative of ours moved to Italy in the late eighteenth century and became a famous artist. I think it must have been Leopold Pollak, the architect who helped design the Villa Reale and the façade of Milan's cathedral.

My mother was descended from Spanish Jews who had been in Prague a long time, likely centuries. My maternal grandfather, David Löw Schlosser, lived on Meisel Gasse, one of the narrowest and gloomiest streets in the old Prague ghetto. The apartment was like a tunnel, the business located in front and the living space in back. Eleven children were born and raised there. I sketched the building shortly before its demolition. I still have the drawing.

Pollak seemed to be considering whether to look for the sketch. Ardent collector and cataloguing specialist that he is, I doubt he would have had to search long. Without warning, the words poured out of me; I didn't care if the moment was fitting or not. Please, I beg you, I erupted, without any attempt to dress things up, please come with me. He looked at me—or through me—with wide eyes and continued his story.

The street wasn't more than ten feet wide, with tall buildings that blocked out the sun from the first-floor apartment.

My grandparents' generation grew up in this perpetual murk. It wasn't until years later, when Jews were finally permitted to live outside the ghetto, that my grandparents left that house and moved to Stockhaus Gasse. One day my father came home with a pretty young lady—my mother. They were all particularly taken with her hands. The family business was located at one end of Lange Gasse, on the left when approaching from the Old Town Square, in a building known as the "Red Crab," its façade adorned with a sizable crimson crustacean. Business was brisk, largely thanks to my grandmother. They were soon able to move operations several doors down, closer to the Old Town Square, and eventually one of my uncles, the eldest son, moved to Bergmann Gasse. The emancipation of Jews in Prague followed this very trajectory, you see. By the early seventies, the few who remained in the ghetto were either involved with one of its many synagogues, the Jewish Town Hall, its hospital and charities, or were orthodox Jews who clung to their home. Grandfather Schlosser was chairman of the Zigeuner Synagogue board. The shul had nothing to do with *zigeuner*, or gypsies—a man by the name of Zigeuner founded it in the seventeenth century, hence the name. My grandfather had a dry sense of humor and a passion for justice that itself bordered on the unjust. He appreciated the importance of family history, a rather unusual habit in those days. What little information I have comes from him.

In tenth grade I fell ill with endemic typhoid fever, caused by Prague's contaminated drinking water. My convalescence

cost me an entire semester, and I was forced to repeat a year. In retrospect, I believe the disease can be credited with broadening my horizons and, more importantly, providing a sense of clarity. I had been drifting along till then, but after my recovery I was more determined, in both action and thought. I became one of the school's top pupils in Greek. Mathematics, on the other hand, remained a struggle. But in art history, I felt as one perishing with thirst feels as he sups from a spring without knowing whence the water comes.

He gets caught up in pathos sometimes, K. says, and he'll start using dated language or unbridled gestures. I think his emotions get the better of him. He also wants to share, and thereby preserve, whatever is unleashing these feelings, including the force with which it does so. Pollak erects monuments with such phrases, and in Pollak's world, monuments serve as milestones, whether of cultural progress or an individual life. They are what counts.

My greatest dream was to ramble about Rome's monuments. As a student in Prague, I not only devoured the Baedeker, but read other books about Rome, its buildings and artworks, whatever I could get my hands on. Even then, I was captivated by the Laocoön group. After all, there is a poignancy to the piece, something about it that transcends the ordinary. Isn't that right? I could sense it, even in faded reproductions.

I realized, K. remarks to the monsignor, that you would be wondering what had become of us. By then I also realized, however, that Pollak had to finish his story before he could

leave a place so intrinsic to it. Someone here in the Vatican recently spoke of the martyrdom of patience. I was reminded of that as I sat there, damned to listen against my will on the one hand, enthralled by what I was hearing on the other. Whenever my gaze wandered toward the window, I felt the urge to stand up. But I remained seated.

Pollak was born on a Sunday, a day that held no particular significance for a Jewish family. On Saturdays, meanwhile, the household did observe what he called a day of total rest. His father attended services in a top hat, his mother in formal dress. In the city of his birth and childhood, however, the city he loved best—until he came to Rome, that is—Sundays were important.

Prague was especially beautiful on Sundays, he said. I would often climb the Old Castle stairs to the cathedral or simply wander around the Hradčany district, admiring the view and the stillness before the peal of bells blanketed the city, loud, penetrating, glorious. That same sound would make me feel right at home when I arrived in Rome. What day is today?

The question surprised me, K. says. I found it hard to believe that he didn't realize it was Friday.

No Sunday was complete, Pollak continued, without visiting the flea market along the broad thoroughfare that ran through the ghetto. Peripatetic sellers of used books would display their wares on improvised benches. Among them was an old merchant whose two daughters were known citywide for their beauty and who would assess a book's value based on

its length and format. You could often pick up rare books for a few kreuzers, old editions of German classics, for instance. It proved the cornerstone of my personal library.

I have always been drawn to the venerable. I once watched as parchment Torah scrolls—entire scrolls as well as smaller sections retired from use—were sprinkled with lime and buried with utmost solemnity in the Jewish cemetery by the Old-New Synagogue. I couldn't help myself. I simply had to take one of those fragments. There is something irresistible to the venerable nature of such parchments, not least when faded with age. The piece I took had an unusual shape. It immediately suggested the Star of David to me, a shimmering, faded blue star torn at random from the Torah. The Seal of Solomon. Were you aware that the two triangles comprising the Star of David represent the relationship between man and God? One triangle points downward as a reminder that our life comes from God. The other points upward, because we will return to God. Twelve points for the twelve tribes of Israel; six triangles for the six days of creation. In the middle is a hexagon. I see it whenever I look at the Torah fragment. The hexagon symbolizes the Sabbath, the seventh day, man's day of rest. Tomorrow is the Sabbath, he said, confirming my suspicion that his asking the day of the week had been rhetorical.

An excitement, no sign of which was evident when I first entered the apartment, had seized the aged body. His voice rarely cracked now. It was getting harder and harder for me to imagine his ever returning from his story to the pressing situation at hand.

In the Middle Ages, the Star of David was used as a talisman to ward off danger, the danger of fire in particular, he continued. Perhaps the only reason I associate this haphazardly torn fragment with the Star of David, though, is because the symbol has such a distinct presence at the Old-New Synagogue. The star—and this is something very few people know—was first used there, at the Old-New Synagogue in Prague, before its use spread across Europe. I wonder if the fragment will remind you of the Star of David, too, Pollak asked, one of the few times he addressed me directly. That was all he said. Much as I have mulled it over, I can't make heads or tails of the comment.

When I was young, Czech was gaining the upper hand in Prague, Pollak said. The oldest German university found itself in a country where German was no longer the predominant language. All my life I have revered the language, indeed all things German, quite possibly because from then on, the use of German in my hometown dwindled with every passing year, every passing day, and with every child born speaking Czech. Perhaps it explains why Goethe became my most important guide and the one who pointed me toward Rome. He described Rome, showing me the city long before I ever saw it. With his help, I, the German, found my home here and made my peace. While peace was still afforded me, that is.

We're safe as long as we keep reading Goethe. Language is the most important thing we have, beside art. Czech speakers first gained the majority in local Prague government during

that time as well. Sometimes I think if only I'd been born ten years earlier, I'd have been born a member of the majority in Prague, not part of the minority, and perhaps life would have run a different, easier course. Majority is always easier. Isn't that right?

Three quarters of the Germans in Prague were Jewish. Their devotion to the language, as introduced to them more than a hundred years earlier by Moses Mendelssohn, was touching to behold. This beautiful language was spoken at the German Casino, a social club that served as the center of German life in the city. There was a great deal of respect for the German Empire in Prague, far greater than any affinity to Vienna. People were terribly impressed by the Prussian victories of 1866 and '70–'71, the latter in particular. Jews played an outsize role across sectors, considering what percentage of the population they represented in Prague; they powered German-language newspapers like the old *Bohemia*, the *Prager Tagblatt*, *Prager Abendblatt*, or *Montagszeitung*, but were also active in theater, at the university, and in banks, commerce, and other large-scale industries. Moreover, they were the standard bearers of Germanness in Prague; something the Czechs, now in the majority, held against them.

Do you know, he asked, why I have kept a diary my whole life, since the day I turned twenty? He wasn't expecting a response. I'm not even sure he looked at me.

As a young man, for whatever reason, my father had a leather-bound notebook made, his name engraved proudly on the cover. Abraham Pollak. A blank book that just lay

about from the moment he got it. My father's name, followed by all those white pages. I don't know what he had in mind or how the idea occurred to him. Perhaps it was all he had, or perhaps he was trying to tell me something. In any case, on my twentieth birthday my father gave me that book, a book of blank pages titled *Abraham Pollak*. I began to write in it without a second thought. It's impossible to own a blank book with your father's name on the cover and not use it for something, and what better use for it than writing? Isn't that right? The blank pages stared at me expectantly and I stared right back, but not for long. Writing came easily to me. I was twenty. At that age, we think anything is possible—especially good things.

Pollak still stood at the bookcase, Baedeker in hand, as he told me about the blank book. I still sat in my armchair, looking up at him. At some point he returned to the window with the Baedeker. He gazed out at a darkening Rome.

THAT'S RIGHT, he said. It was that very car model.

The car had long since moved from its spot outside the palazzo. The view out the window, it seemed, had triggered the memory of the vehicle parked on the street below.

You see, those were historic moments for me, he said. Waiting with Richard Strauss on the side of Via Appia until the chauffeur mollified the engine or got it running again. One does not forget such moments. Take the way Strauss compared the Throne of Venus in Holland's Thermenmuseum to a Mozart sonata, or the time we were driving to Palestrina and someone asked where Giovanni Pierluigi da Palestrina was buried, to which he responded, in Hans Pfitzner's opera.

Hauptmann, too. He simply appeared one day, his visit an utter surprise. Try to imagine Gerhart Hauptmann sending notice midday, completely out of the blue, that he will be arriving that afternoon. He called at half past six with his wife and their youngest son, Benvenuto, who is a colossus, incidentally. One could easily have mistaken the gentleman seated beside this giant for an elderly Goethe. Rather long white hair, clean-shaven, good coloring, blue

eyes. He greeted me warmly. He said he'd heard a lot about me and gone to great lengths to find me, searching for three days. The very next day I went to the Grand Hotel to pick up Hauptmann and his wife, sans colossus. Our first stop was the museum.

He seemed suddenly to become aware of the fact that he was still holding the Baedeker. He returned to the table and set it beside the splendid volume he had pulled from the shelf earlier. He sat back down. On the table lay a green folder containing a stack of papers, a leather eyeglass case with the words *Augosto Malatesta, Ottico* embossed in white, as I recall, and two other books. The handwritten title on one read *On the Hundredth Anniversary of Goethe's Death*, the word *Hundredth* in capitals, *by Ludwig Pollak* written below, and then, in parentheses, *(Rome)*. The pale blue embellishments on the other book cover are seared into my memory; I certainly looked at it enough times. The publisher was the Metropolitan Museum of Art, its title *The Classical Collection*. Seemed to be what he'd been reading of late.

Sitting at the table with Pollak, I was reminded of going to a casino once with a friend, back in our university days. Roulette. My friend played often and passed on a word of warning that night: Never sit down at the roulette table. Always remain standing. It was the only way to maintain distance from the emotions unleashed by the little ball and stack of chips on the green felt tabletop. When you sit, you become part of the field and all is lost. I knew there was a reason I had stood by the door for so long.

Museums are wonderful, Pollak said, but they pale in comparison to private collections. Museum directors pale in comparison to private collectors. What these men have contributed to scholarship and to museums—

He didn't finish his thought. Pollak will often do that in the middle of a story. His voice reveals that, were he to continue, words would follow that touched his innermost self. Recounting this to you now, monsignor, I get the feeling he was trying to impart to me something he fears could be forgotten. The legacy of collectors. He considers himself their trustee. The catalogues are their bequest.

Private collectors, he continued, constitute the necessary correlate—that was the word he used—to the major state and city museums.

Breaking into the world of Roman collectors was arduous work. What I lacked in means I had to make up for in knowledge and intuition and, above all else, careful observation. Yet another lesson I gleaned from Goethe. While the rest of the art world was fixated on the likes of Guercino or Guido Reni, Goethe spent his first stay in Rome, the two years from 1786–88, collecting the sublimely simple medals and majolica of the quattrocento and early cinquecento that others disregarded.

In the macrocosm of the Eternal City, Pollak said, private collectors form a sort of microcosm, a world unto itself. Foreigners have always been drawn to Rome. The monuments of antiquity found here speak to visitors in a way one does not see in other cities, and visitors have never been content

to simply study and admire the ancient works—they have always wanted to own them. Collecting is in the air. Very few manage to resist its magic. Collectors tend to be foreigners, though, rather than locals. He who lives amid abundance rarely becomes a collector. Once a man starts, however, there is no turning back. What could possibly surpass the exhilaration a collector experiences after making a significant find or finally acquiring a piece he has long coveted and lost sleep over? This realm of terrific, silent joys has revealed itself to me as well, Pollak said; it may be the only joy that truly exists. Collectors, he continued, are the most passionate people on earth. People prepared to venture into the foulest corners of the criminal code to take possession of a teacup, a painting, or some other rare objet d'art.

The slightly stilted tone, the declamatory lift in his voice, led me to suspect that the last few words he'd spoken were a quotation. I assumed Goethe, although it didn't quite sound like him. Pollak solved the mystery without my having to ask. Balzac, he said—just the name—only to return to Goethe.

The heart of my collection is Goethe, he said. It always has been. My whole life I've collected things related to him, Weimar, and classicism. The fifty-six-volume definitive edition is in the next room, a gift from Frau Frida Mond. Frau Mond also arranged my meeting with Schiller's great-grandson, Alexander von Gleichen-Rußwurm. At Frau Mond's request, I brought all of my Goethe memorabilia to her house. She invited Baron von Gleichen-Rußwurm to join us. I must admit it felt rather strange showing him pictures of

his great-grandfather's dearest friend. We sat together in Frau Mond's home, just as you and I are sitting at this table with these books, and discussed both heroes as we studied pieces from Goethe's estate.

I own forty autographs in total, twenty-seven written by Goethe himself, the remaining thirteen penned by close associates. Three I acquired in Copenhagen from the estate of the Norwegian painter Johan Christian Dahl. I obtained a lock of Goethe's hair from his daughter-in-law's belongings, with irrefutable proof of authenticity, followed later by a second lock of hair.

Pollak stood up and looked straight past me. To my surprise—I would have tried to intervene otherwise—he repaired to the next room, moving slowly through the open double doors and bracing himself briefly on the doorjamb.

Left alone for a time, my worry grew. The calming effect provided by the cordon of Pollak's stories was lost the moment his voice stopped. I thought I heard noise coming from the stairwell, harbingers of a raid on the apartment that would have meant the end of us both. It was a false alarm, though. I'm sure it didn't take Pollak long to return from next door, cautiously carrying a gray archival storage box, but to me it felt like an eternity. He placed the box on the table among the books. He removed the cardboard lid with a practiced hand, set it aside, gingerly peeled back several layers of tissue paper, and withdrew a green folder identical to the one already on the table. With nearly ceremonial air, he opened the newly exhumed folder. It contained a letter from

Friedrich Theodor Kräuter to Countess Hopfgarten regarding a celebration in Goethe's honor on November 7, 1825, as well as a four-line poem in Goethe's own hand. It's quick to memorize, if one so chooses.

The Soldier's Consolation

No! in truth there's here no lack:
White the bread, the maidens black!
To another town, next night:
Black the bread, the maidens white!

After reciting the quatrain, Pollak paused solemnly, like a priest following an important prayer in the liturgy. His eyes shone with youthful spirit as he produced another yellowed manuscript from the green folder. From where I sat, all I could see was handwriting in ink; I couldn't read what it said.

And with that, he said, I came to possess the precious signature of mankind's single greatest mind.

You Germans and your Goethe, the monsignor cuts in. It seems a relationship that has more to do with religion than with reading.

You may be right, K. replies. Pollak views Goethe as an indomitable force, the towering universal hero: unmatched because unmatchable, flawless because infallible. He doesn't even discriminate between his greatest works and those

of "The Soldier's Consolation" variety. Goethe is Goethe, just as the sun is the sun, and Rome Rome. He quoted his own diary to me from memory. Götz, Werther, Epigrams, Egmont, Faust, he had written, you all parade before me, and of him who brought you to life I now own a handwritten manuscript.

My point exactly, the monsignor says.

Pollak pulled out another piece of paper, K. continues, this one with a black border, because the Grand Duke had just died, he explained to me. Goethe's seal was still discernible.

A precious treasure, Pollak said. He went on to recount tracing Goethe's steps on a trip he took after completing secondary school: Strasbourg, Heidelberg, Frankfurt, Weimar, Goethe's tomb, then Ilmenau, where he'd had a lengthy conversation with the mayor, whose father had been there when he was nine for Goethe's final birthday celebration. I called on Juliane Glaser too, Pollak noted. She met Goethe in Marienbad when she was sixteen. I had the privilege of holding a hand that had held his. Imagine that. When I visited Frau Glaser, she was eighty-four years old. I like the elderly; I always have. I have always felt drawn to them. Something lives on inside them that others have long forgotten. After they're gone, the one place left for the past to exist is in art. And books, of course.

I thought of Fröhner, says K., and how Pollak would have loved to kiss his hand like young Mendelssohn had old Goethe; I thought of Bode, all the private collectors who had

enlisted Pollak to write their catalogues. A world of venerable old men, a reverent Pollak in their midst. The fact that he, too, is now an old man seems immaterial to him. Revered above all others, of course, is the epitome of venerability himself, Goethe.

On the eightieth anniversary of his death—Pollak was referring to the day on which, eighty years prior, the one-and-only had closed his great, all-seeing eyes and become truly deathless—on that day Pollak hosted a grand dinner. Augusto Jandolo read from his comedy *Goethe a Roma*; the autographs were arranged in a display case. On the centenary of his death in '32, Pollak offered to loan the city his autographs for an exhibit. No one wanted them. Not from him.

He had closed the box again by this point. He placed his hands flat on the lid as if it had to be held down.

I purchased my final Goethe by mail in '33, from Hellmut Meyer & Ernst in Berlin. An envelope, the sender identified in his own hand, *JW* dot *v* dot *G* dot, with his wax seal.

It felt like a conclusion, or at least a break. I stood and plucked up my courage. Please, I said, and I addressed him by name for the first time, Herr Pollak, please, I said, wake your wife, your daughter, and your son, and come with me. My voice was hushed. They're worried about you in the Vatican, and with good reason. We must leave now. Immediately. Surely you understand. We're in danger.

We both stared at the table, as dictated by his gaze. Arranged there were the Baedeker, the gray archival storage

box, the book from the Metropolitan Museum, and those two magnificent folios. He was still leaning on the box.

Are we really? he asked, without looking at me.

Yes, I said, we are. Really.

I felt I had finally gotten through to him. Hope returned that I would get out of this fix, after all, and accomplish my mission. I checked my watch and was alarmed by how late it was.

Ah, he said, but hasn't it long been too late?

I refused to entertain the thought that I was losing him again. I cleaved to the feeling of relief that had now joined those of tension and fear.

Look here, he said. I'd like to show you something else.

I watched him pull another large book from the shelf and set it on the table. The hope I had laboriously resuscitated was not yet lost amid the disappointment, dread, and exhaustion I now realized I felt.

And then we'll go, he said, his tone almost off-hand.

He turned to the middle of the book he had just pulled from the shelf and positioned it so I could easily see.

My catalogue of Alfredo Barsantini's bronzes. They gave the collection to Mussolini in '34, along with the catalogue. Three specially bound gift editions were produced—one for the king, one for the queen mother, and one for the pope. The presentation to the king occurred behind my back. That was new. As he who had done the work and knew most about the collection, I had always been welcome at such events. Suddenly that was no longer the case. At least the pope would

still receive me in person, and yet as I came to realize, that was the beginning, the beginning of—

He hesitated.

—of the end.

He had always done lots of work for embassy associates, he added. They came and went. The same could be said of clients, forever coming and going. Barracco, though, was always there.

I had been waiting for him to mention Barracco, another denizen of Pollak's Mount Olympus of venerable old men. It stood to reason, and was by then obvious to me, that his story would be incomplete without discussing Barracco. Barracco, the museum, and the arm. Then we could finally leave. So when I heard the name, I almost breathed a sigh of relief.

THERE ISN'T A MAN in Rome who has done more for the study of antiquity than Baron Giovanni Barracco. I regarded him as a mentor and doyen, and not only when it came to antique sculpture. He taught me much about Italy's more recent history as well. There were stretches of time when I called on Barracco almost daily, always in the early evening. Between the serenity of his character, his refinement, grandezza, and educational pedigree, this venerable old man was the prototype of a human breed that has since died out. No one seems to realize just how much is lost with them. What I did for him does not begin to compare to everything he gave me. I consider myself lucky beyond measure to have been able to sit at his feet and heed his words.

Rome was rebuilt after being declared the capital of a newly united Italian nation in 1871. Entire neighborhoods were demolished, unearthing no end of antique sculptures. State and city museums simply did not have room for it all, and much of the excess—often some of the best pieces—went to the cleverest of private collectors. Barracco, who never married, made use of his handsome earnings to build a remarkable

collection, which he resolved to donate to the city of Rome before he died. He funded the construction of a museum, designed by Roman architect Gaetano Koch. The Museo Barracco opened in 1905 on Corso Vittorio Emanuele.

In late 1913, on one of the last days of the year, Barracco sent for me. I found the aged gentleman lying in bed, his right eye bandaged. He extended an emaciated hand toward me with some effort. He felt death approaching, he said. Of paramount concern was that his prize creation, the museum, continue to be operated after his fashion. There were none better suited to the task than I, he asserted. I was sensitive to his interests and ideas, he continued, and knew every piece in the museum, every volume in the library like none other. And it was true. Barracco asked if I would serve as custodian of the museum. I accepted the duty gladly and without remuneration, of course. Barracco thanked me, wept, and fell asleep. I was thus made honorary curator of the Museo Barracco. And I have not yet fulfilled the responsibility.

Pollak spoke those last words very softly. He was visibly fighting back tears. He changed the topic.

I could sense early on—and in time they made it abundantly clear—that I was not welcome at the lectern. They didn't want me at the university. And one must accept his fate. Isn't that right? Yes, one must accept his fate. Though I did always remain a scholar at heart, just not at the lectern.

That left dealing. I first came to Rome on a scholarship in 1893. It was a wholly different atmosphere than in Vienna. I was beside myself, thrilled to be standing on cherished

Roman soil and seeing all the great works of the past. My dream had come true. I was young and free to travel. That later worked to my advantage, my many travels. Each time I returned to Rome, I had to find a new place to live, until we became a family and moved to Palazzo Bacchetoni.

Luckily for me, I soon recognized that they would never accept me and became a dealer without delay. I didn't waste any time, unlike my old friend from Prague, Arthur Mahler.

And with that, Pollak was off on another tangent.

We were classmates at the German Piarist school in central Prague. While older boys, grades ahead of us, were still playing in the park like children, Mahler had committed *Faust* to memory and read all of Schopenhauer. He studied archaeology at the German University in Prague. In Austria's first-ever general election, he ran as a Zionist candidate in the electoral district of Tremblova, in Galicia, for a seat in the Imperial Assembly. What with his long black beard, he even resembled Theodor Herzl. His stumping in Tremblova would turn into a victory parade. Mahler was captivating as an orator; he won by a wide margin. He held great authority in the Imperial Assembly, despite how few Zionist representatives had been elected. Shortly before the election, a petition to nominate Mahler for a professorship in Prague was rejected, even without the possibility of tenure. Not enough teaching experience, they said, but that wasn't the real issue. An ultra-German contingent of students was displeased by his avowal of Zionism. They demonstrated against his lectures, making it nearly impossible for him to instruct in Prague.

Faced with the quandary, the education ministry decided to transfer Mahler's *venia legendi* to Czernowitz. That was where old Austria sent its teachers who became problematic for one reason or other. Being Jewish was reason enough. Mahler relinquished his academic aspirations in outrage and dedicated himself to legislative work and writing editorials for newspapers in Vienna and Budapest. In Prague, people sniped that Arthur Mahler, King of the Jews, would lead all the Jews to Palestine. Then one evening in 1916, I read in the Viennese *Acht Uhr Abendblatt* newspaper that he had died two days earlier and already been buried in secret. I couldn't believe my eyes.

As an art dealer, I found and recognized many great pieces, then brokered their sale, often to major collections. I discovered the sculptor Myron's Athena, now housed at the Liebieghaus in Frankfurt, but that's another story altogether. The same goes for Copenhagen. I was helpful. I often found what others were searching for. I procured, purchased, and presented objects to the appropriate people. I did this my entire life and always kept quiet. The more interesting the deal, the more discreet the dealer. One must abide by this rule. Carl Jacobsen, founder of the Ny Carlsberg Glyptotek in Copenhagen, once wrote to me, *You are an archaeologist and deal in antiquities, I am a brewer and buy antiquities; different principles apply to deal making and between dealers than between doctors.* He was right about that.

To become a true connoisseur, though, there is something else one must possess that very few people do: a special

intuition that Pollak describes as a *flair for telling authentic from fake.*

I considered just how much Pollak found over the course of his professional life, says K., all the things he recognized that others overlooked. He always seems to know exactly where a piece belongs. If anyone demonstrates this Pollakian flair for telling authentic from fake, it's Pollak himself. He is a virtuoso of seeing. That's what someone at the Vatican Museums recently dubbed him. He himself calls it an inexplicable God-given talent, the way one might be born with poetic or artistic talent. He quoted the Roman adage *Orator fit, poeta nascitur.* He interprets that to mean *One can learn to speak, but the poet is born a poet.* The same pertains to the poet of seeing, it occurs to me, says K.

It was as if things were just waiting for me, Pollak mused. There are many things only a dealer will see. When all that matters is that you spot good pieces, when everything depends on your recognizing them as such, that's the moment you start seeing truly extraordinary things hidden in plain sight among the ordinary. You will only recognize them when your survival depends on it. Nothing befalls the bigwigs at the lectern—there they were again—when they make a mistake. A dealer cannot allow that to happen. That's why they came to me. They wanted me to appraise their pieces, write their catalogues, show them around Rome. Because they knew I could never afford to make a mistake. Like a mountaineer, for whom a single misstep can result in

his plunging tumble. They felt safe working with me. And they were.

I found the Pastoret head, the herm of a Greek general, the day I arrived on my very first trip to Paris. That was in '04, so not long after the arm. It was just lying there at an art dealer's. Others had searched for the herm for years. It's in Copenhagen now, at the Ny Carlsberg Glyptothek. In 1910 came the archaic horse's head, then in '13 the early Christian funerary glass with a gold base depicting Christ between Saints Peter and Paul. That piece was first found in 1720 in the Catacombs di San Callisto, then held by the Biblioteca Vaticana before it was stolen sometime in the nineteenth century. I saw the glass, recognized and bought it, then presented it to Monsignor Misciatelli in the Vatican. A guard led me to the monsignor's downstairs chambers, to the right of the Courtyard of Saint Damasus. Beautiful halls with old frescoes, very comfortably appointed.

I interjected, says K., that that was exactly where we were expected—he, his family, and I—but he didn't react. Beautiful halls was all he said, and that the glass was a gift to the Vatican.

I had a long audience with Cardinal Secretary of State Merry del Val, Pollak went on. I waited in an antechamber with red wall coverings and drawn draperies, and was then warmly received by the cardinal secretary of state. He thanked me for the gold glass on behalf of the pope. I had to recount the story of the find in detail and stayed for at least a quarter of an hour, maybe longer.

By then, says K., my hopes had dissipated that Pollak meant only to show me a compelling entry in the last volume he had heaved off the shelf, and would then fetch his family and depart for the Vatican. Pollak had plunged back into the flood of memory. He was seated again, too. I remained standing at first, then sat back down myself. He watched me, but showed no sign of whether he counted my sitting down as a personal victory, and simply continued with his tale.

The gold glass also led to an audience with the pope. I went to the Vatican in the morning; the audience was at eleven. I waited for an hour with about fifteen other people in a vestibule hung with Gobelin tapestries, then we were ushered into a hall known as *tronetto*, after the small gilded throne there. Monsignor Ranuzzi was the papal *maggiordomo* at the time. He waved me over and intimated that I should stand with him beside a little door. The pope appeared on the threshold in white vestments, the white skullcap resting on his white hair. All in attendance dropped to their knees. Monsignor Ranuzzi introduced me to the pope, who clapped me on the shoulder and extended a hand for me to kiss. *Va bene, va bene*, the pope said, and smiled.

Telling this story now sounds almost like a dream. Isn't that right? The pope appeared gaunt, I thought, hoary, his face like parchment. He issued his blessing at the end, then turned to leave, patting a little boy on the head as he passed. Before finally disappearing, he allowed me to kiss his

hand once more, much to the resentment of the others, the Capuchin friars in particular.

His extensive talk of the Vatican provided an opening, says K. It was the opportunity I had been waiting for. I assumed as urgent a tone of voice as possible and reminded him that that was exactly where we had to go, posthaste. The flood of memory, however, had whisked him away.

In April of '20, I married Julia, Julia Süßmann. She's sleeping. We'll let her sleep. She's very sick. Diabetes. Frau Süßmann is diabetic. Do you know, Pollak asked, how a Jew in Rome gets his hands on insulin? The answer is simple. He doesn't. We have gotten some from Denmark, through Jürgen Birkedal Hartmann. All he wants is to discuss his collection with me. But I need his insulin. Because my wife needs it. That's what art dealing has come to.

The years my family and I were banned from Italy, 1915 to 1919, were very dark indeed. That darkness lingered in our bones for a long time. How could it have come to this, I asked myself time and again. Until I found out. It was an inconceivable confluence of hatred, envy, ignorance, and malice, a structure they built to oppose me. There were decent people, too, who stood by me, but ultimately it wasn't our dear old friends who came to the rescue.

He scoffed quietly after uttering these words.

They were too afraid to show their faces at first. There is much I would have been spared, had Barracco been alive at the time. Still, we must consider ourselves lucky to have enjoyed his presence as long as we did, and to have sat at his feet.

There it was again, that Pollakian pathos.

Help came in the form of decent people who recognized personal persecution when they saw it, like Wilhelm von Bode. He authored a statement extoling my many achievements across Italy in my defense against the sequestration of my collections and its attendant accusations. I didn't even know what they were.

What has always fascinated me about the term *sequester* is how the word captures both the agent and his act, derived as it is first from the Latin *sequester*, meaning trustee, then Late Latin *sequestrare*, or to hold in safekeeping. A word for executor and execution. A horrible word. *Sequestrum* is of course a related term. *Sequestration* refers to private property seized and maintained in custody by some higher authority, while a sequestrum is a fragment of dead bone lying within a cavity in the human body—something remaining in place that no longer belongs there.

News of my collections' sequestration reached me in Vienna in the summer of '18. I received a letter one afternoon from Count Pálffy, writing from Bern to inform me that the prefecture of Rome had issued a prefectural decree on June 30, by which everything I owned had been seized. Cavaliere Dottore Ernesto Roncalli was the appointed sequestrator. What I long feared had now come to pass. A heavy blow, yet another to endure.

Upon my return to Rome, I immediately liaised with all manner of notable figures who might be of help, but the sequestration was not lifted. As if to imply that this new

Rome no longer wanted me—my collections, yes, but not me. But I stayed. I have always stayed, come what may.

In November of '19, *Idea Nazionale* ran an article against me. I contacted the new Czechoslovak ambassador to the Quirinal Palace. There was a Czechoslovak ambassador now, which itself took getting used to. It soon became clear I would find no support there; the official they had dispatched was a sworn enemy of all Germans and all Jews.

They discovered my correspondence when they seized the apartment, nine thousand letters, all meticulously sorted. At year's end, I am in the habit of gathering the missives I've received from those individuals most important to me and bundling them by sender. Pollak listed several names of those whose letters he treated in such fashion. I'm certain the sequestrator expected the letters to be riddled with political secrets, because I was friends with diplomats and passed freely in and out of the German, Austrian, and for some time even Russian embassies. The sequestered letters were translated. Not a hint of political intrigue was to be found. How could there be? I've never been the least bit interested in such things. Of course they knew I was an art dealer and the ambassadors were consulting with me on matters concerning art, but they were determined to find something incriminating.

Most despicable among them was the erstwhile director general of antiquities, Corrado Ricci. He wrote a book titled *Art in Northern Italy*. I translated it into German. Thousands of copies were sold. Of all people, it was Corrado Ricci

who denounced me. The magistrate ultimately dropped the charges against me after a year-and-a-half-long investigation—during which neither I nor anyone else was questioned—citing the statute of limitations. Nevertheless, they kept lobbing all manner of accusations, none of them concrete, so there was no way for me to defend myself. It was pure warmongering and boundless ignorance, an administration of justice reminiscent of the Middle Ages or Russia.

Or the Dreyfus affair, K. pauses to comment. That must be what first reminded me of Dreyfus when I started my story earlier, this sustained furor in wanting to rob a successful, well-established Jew of everything he has, his social standing in particular.

I didn't suspect a thing when I returned to Rome in October of '21, Pollak recalled, only to learn that the government had issued a deportation order that summer, without giving any reason. My Czechoslovak legate offered little to no support, as expected. It was Italians who helped, most notably Bartolomeo Nogara, the director general of the Pontifical Museums and Galleries. My expulsion was deferred, and I was finally granted access to my file. It was the first time I saw the allegations against me. In an act of boundless villainy, select passages from my letters were ludicrously misrepresented or intentionally misinterpreted, to say nothing of sundry errors in translation. For instance, the documents claimed I had regularly smuggled pieces out of the embassies, when what I'd been doing, of course, was conducting expert appraisals. The entire thing was ultimately suspended *sine die*.

It sounded like it had happened yesterday, not twenty years ago. The whole thing remained incomprehensible to him and his outrage was still palpable.

You see how I suffered, Pollak said. Had times not been so difficult, and had I been solo, I'd have been on my way. I'd have left without hesitation. I couldn't do that to my family, though—subject my wife and three delicate children to an uncertain fate on top of the misery we were already enduring.

That, he concluded quietly, his tone deeply embittered, is the fate of someone who never harmed a hair on another man's head, who always wanted to help others and did indeed help many. That—Pollak continued speaking in the third person—was the thanks he got.

And then, after we had so hoped things were finally improving, they got worse. Next came the deportation order. An especially dark day among many dark days. At least Bartolomeo Nogara was there. He came from Milan to the Vatican Library as a *scrittore* in 1900. Twenty years later he was named director general of the Pontifical Museums and Galleries. His influence was far-reaching, especially after his old friend Monsignor Ratti became Pope Pius XI.

You know, I tried yet again, they'll be terribly worried in the Vatican where they're awaiting us, says K. He didn't hear me. He clearly wanted to ensure I got the right impression of Nogara. It finally registered that he wasn't even speaking to me. He needed someone to listen, and anyone would do. It just happened to be me. I just happened to be there. There's no reason for him to care what I think of Nogara. But he

does care. I was a stand-in for everyone who needed to hear his story. I was a witness. Because he made me one. I now understood that this was why he was making me wait, that he had no intention of coming with me until he'd said everything that needed saying.

When the position to head the Vatican Library opened up, the pope asked Nogara whom he would recommend as a successor. Nogara nominated a fellow Lombardian, the historian Achille Ratti, prefect of the Biblioteca Ambrosiana in Milan at the time. The Vatican appointment was the start of Ratti's career—archbishop of Milan, cardinal, pope. He never forgot what Nogara had done for him. Nogara and his family were always housed in close proximity to the pope's private chambers. Rumor has it they used the familiar *you* when it was just the two of them visiting in the evening.

I once had the honor of hand-delivering a publication of mine to the pope in his private library. It was my book on Italian bronzes, the first of its kind in Italian, incidentally. The revered pontiff went through the entire book with me, page by page, making insightful observations and asking questions. When we'd finished he produced a red case from a wall cabinet and handed it to me with the words *bronzo per bronzo*. One bronze for another. Inside was a large bronze medal bearing the pope's portrait.

I expected Pollak to get up and fetch the coin from somewhere, but he remained seated.

One mustn't forget Pius XI's battle against race theory, he said, and of course his move to Castel Gandolfo when

Hitler came to Rome in May of '38. The entire Vatican City was closed down during that time.

At the Polish Academy in Rome in the early thirties, I once spoke at length with Bartolomeo Nogara about South Tyrol and the Hitler movement. Nogara quoted the pope, who just days earlier had remarked that the prevailing *furor teutonicus* would persist, whereas past instances of *furor gallicus*, though recurrent, were always brief. All one could do was wait and see, the pope had said.

To wait and see. In its repetition, the expression became a cruel, injurious imposition. It became a punishment.

The fervid swell of nationalism began with the March on Rome in '22, said Pollak.

In other words, by the time the sequestration order was lifted he could already sense the tides had turned. That was in the spring of '23.

Even then, the matter wasn't fully resolved. During that time, for seven years, until the summer of '26—a biblical seven years, as Pollak put it—he did not leave Italy once, for fear of not being allowed to return.

As soon as circumstances allowed, Pollak bought two houses in the mountains, near Bolzano. From then on the family summered there. They felt safe. By '26 he could travel again and thus resume business, only there wasn't nearly as much purchasing power as before the war. Then came the global economic collapse. It's of no use for the dealer to travel when no one's buying, Pollak said. Nevertheless, he returned to Copenhagen, Munich, Berlin. Eight antique

sculptures that had spent the last twenty years on his balcony in Rome made their way to Berlin in 1926. He went back repeatedly—in '27, '28, '30—always visiting old Bode, who didn't like Rome, so Rome came to him. He called on the painter Max Liebermann, too, in '28, at his house next to the Brandenburg Gate. Liebermann detained him for more than an hour; that's how Pollak put it. It was one of the most interesting conversations of his life.

COLLECTING has always been synonymous with life to me, whether collecting for myself or others. Even during those hideous years in Vienna, I would at least keep an eye out for drawings. There are three things I primarily collected—Goethe, Prague, and Judaism. To my mind, Goethe is culture, Prague is home, and Judaism is my destiny.

His collections must be extensive, says K. I don't know where they're currently housed, beyond what's in the apartment.

The most valuable piece in my collection of Hebraica, Pollak continued, is a Haggadah from fourteenth-century Mantua. It is a beautiful object, imposing in aspect but with filigree detailing. I sometimes traveled with it, in order to show experts and learn more about it, but I must admit that I did so in part out of a sense of pride. It's my Haggadah, you see. I took it to Geneva. It's locked in a safe there. It's protected. When the time comes and I'm no longer here and peace has been restored, the Haggadah will go to the Jewish community in Rome. Did you know that the Jewish community here is one of the oldest in the world? I take comfort

in knowing that the Haggadah will return to this place once such passage is possible again. Not only because of its value and singular beauty, but because the Haggadah itself is so important in times like these. Its name is derived from the Hebrew word for storytelling. A guide for storytelling—that's what a Haggadah is. The stories we tell are all that remain in the end, you know. Stories, and art. It's how life goes on. It's what we leave to those who come after. On the eve of Passover, following the order set forth in the Haggadah, Jews tell stories of the Israelites' enslavement in Egypt; they tell and retell stories of their enslavement and liberation, but particularly that of liberation.

I went to the synagogue here in Rome once; first to the ghetto, then to the synagogue. An older blond woman approached and embroiled me in conversation. She said it used to be there were fewer rights, but more religion. Now the inverse was true. It used to be the gates to the ghetto were locked every night, and every murder was blamed on the Jews. Zero rights. Now, though, Jews were public officials, even state ministers, but had lost their religion. That was what the blond Jewish woman said. The doors to the synagogue had opened in the meantime, and I entered. Sitting against the wall was an older man in Oriental garb with a flowing white beard. I was instinctively drawn to him and sat down at his side. We began to talk. He was the rabbi from Livorno. He spoke broken Italian and knew only a handful of words in German. His vernacular was Spanish, as is the case for so many Italian Jews. His name was Ben Halna. He

had intelligent eyes and a fine profile. It took me a long time to pinpoint why he looked so familiar; he reminded me of a Dürer drawing at the Albertina, *The Head of an Old Man.*

The year is 1901. A new century is beginning, you're young, and you think your whole life lies ahead of you. Isn't that right? Anything is possible in that moment. How very vast the world can be. And how circumscribed. How circumscribed—how very circumscribed, in fact—that world has become for my family and me. Back then, at the turn of the century, the world was vaster than ever before. That was when I took my grand tour of the Orient, to Egypt and on to Jaffa. I saw the Jewish colonies developing there. The country is far more cultivated than I'd expected, but the noise. Terrible noise wherever you go. And water. I was surprised by how much water there was. More noise and more water. More life. Isn't that right?

There were vineyards and fields, then more gentle hills with taller mountain ranges in the distance. Beyond them lay Jerusalem. Its name has always prompted an emotional response within me, and now here I was, standing at the Western Wall. Without knowing why, I was moved to tears. Not even the most importunate beggars there could disturb me in that state of transfixion. I thought about grandeur, about ascendency and downfall, about historic justice and the wrongs we endure, about the passage of time, old hopes and fulfillment deferred. If there is anywhere the breath of history can be felt, it's at the Western Wall. I stood there for a long time, enraptured by the mighty ashlars. I later passed

the temple but was only allowed to peek inside. The next day, late in the afternoon, I returned to the Western Wall. Many Jews were there, some in colorful silk caftans with fur hats. They stood there moaning, weeping, praying. Yet again, I was unable to contain my tears.

There's a good chance Pollak was tearing up as he recounted his experiences at the Western Wall, but without any lights on to ward off the advance of dusk in the apartment, colors were gradually fading and contours losing definition.

Word of a planned demolition of the museum first began circulating in 1930.

I wasn't sure which museum Pollak meant, says K., but only momentarily. That story remained to be told. It made sense. Next came the Museo Barracco, then the arm. Then we could finally leave.

The building was barely twenty-five years old at that point. An elegant little temple with an inviting portal, consummate Classicism. Visitors climbed a few steps, then passed between Doric columns into the world of antiquity, an experience without equal, even in Rome.

I visited that museum many times, says K., as I'm sure you did. The monsignor nods. It was a truly extraordinary place as I recall, beautiful and enigmatic. I was especially moved by the head of a satyr, Marsyas, the sight of a bearded man with lowered eyes. His downcast gaze is so intimate, so lifelike and so real, that it captivated me time and again. It's the gaze of a profoundly lonely man who happened upon

Athena's flute, then triumphed in a musical contest by dint of his diligence and talent, only to be punished by the gods for hubris. There's no telling with the gods.

The time had come by '38, said Pollak. The museum was razed. The collection has since been moved to the vaults of the Capitoline Museum for safekeeping. One day, though, it will rise again and the museum will be rebuilt. Surely it will, he murmured. It simply must. Isn't that right?

Which makes it all the more important that we leave at once, I broke in, that we leave for the Vatican now, that we might fight together for your museum's revival.

Hadn't he just expressed something akin to hope for the first time, or at least entertained a thought that extended into the world's future and his own? Surely that implied that things would once again have meaning. I had to convince him that this future would exist only if he saved himself and his family, and that meant acting now. The collection was far safer in the Capitoline vaults than if it were currently on display, I said, in the belief it might subtly underpin my argument.

He fell silent for a spell, which fueled my hope. I couldn't decide between saying more and keeping mum, for fear anything I said would jeopardize things again. It was he who broke the silence.

Mussolini had it torn down. It was barbaric. I regarded that space as the second most beautiful in Rome and in my life. My museum and my hall. Both of them demolished.

—How can you be so sure they're coming?

The question took me by surprise. We were in imminent danger, yet he was dubious?

From various sources, all credible, I stated as soberly as I could. German intelligence has leaked, as I'm sure the gentlemen who were here earlier confirmed, that the Jews of Rome will be rounded up tomorrow—that is, today. Rounded up—

All of them? he asked.

I implore you. Yes, quite possibly all of them. We must assume the worst.

On the Sabbath?

At that, I told him everything. I told him about the list, that *Hauptsturmführer* Theodor Dannecker was behind it, that Adolf Eichmann himself dispatched Dannecker to Rome to solve the Jewish question here, too, as they call it, and that this solution was to be final, as they say. That Dannecker is known for having done just that many times over, always to Eichmann's satisfaction. That they had worked on the list for more than two weeks. And that his—Pollak's—name was on the list, residing at Palazzo Odescalchi, Piazza dei Santi Apostoli.

In other words, all of them, Pollak said.

Please let's go, I entreat you, I said again. He'd been given plenty of time to reminisce. It had demanded a great deal of him, but it also seemed to have bolstered him. It takes an incredible amount of strength to go through with this, to leave home without knowing for how long and what comes next, and without knowing what will happen in the meantime to the apartment and everything left behind,

particularly when one is so attached to the contents of those rooms—I understand all that. Of course I understand that. Who wouldn't understand that? But surely the alternative outweighs—

Tomorrow, then, he repeated.

Whenever they decide it's tomorrow, I said.

Tomorrow, of all days, he said, without offering me any clue as to what distinguished this particular *tomorrow*—today, that is—from any other, beside its being the Sabbath.

How do you know it's true? Pollak asked.

I hadn't anticipated this skepticism. Wasn't it proof enough that I'd come with the car or that Professor Volbach and the other gentleman had been there, and thus clearly knew about the list? Did it not speak for itself that I had stayed and refused to give up? Besides, didn't the details I had just shared confirm what we had long seen coming?

We are certain our information is accurate, I said, otherwise I wouldn't be here.

Indeed, he replied, why are you here with me, of all people, and not at someone else's home? Or are you calling on others as well—perhaps even all the others—before they're detained? There may be others who require help more urgently than I. They may not even come for me. I'm old. What use is such an old man to them?

He was now sitting up in his chair, his back straightened at some distance from the cushion. He looked at his hands resting on the tabletop, surrounded by the objects that had accumulated there.

Besides, he said, maybe one day—no, one day they will, assuredly, want to rebuild the museum, my museum, the sole location where people may behold ancient masterpieces and immediately grasp their import. It's the greatest gift this city has ever received in a history replete with gifts, unsolicited gifts of buildings in particular. Yes, he said, sooner or later they will want to rebuild. And they'll need me for that. Isn't that right?

His thoughts were clearly headed off course again.

They're my children, he said, though they're long since grown. They're frail. They can't work. They aren't allowed to, either, so even if they could, they wouldn't be allowed.

He appeared stricken, waxen and gray. His face had a pleading aspect to it. I don't know how to describe it. There he sat, this old man, suddenly aged by years, looking pleadingly at—I couldn't tell what.

They aren't well, he continued. Would you be well, if you were prohibited from working? And Jews are barred from everything else, too. I couldn't possibly wake them, not after they've finally found rest.

He leaned back again and closed his eyes.

It's different in the Vatican, I quietly offered, and you know it. What you've described has never been the case there, and still isn't. You will be safe there. And they're expecting you.

I sleep very little, he said, barely at all now. It must be nice. How could I possibly wake them when the world they'd wake up to is the world they'd wake up to?

I didn't know how to respond. We sat there in silence until he, rather than getting up and rousing his family, resumed his tale.

There were several people he was determined to mention, something I came to recognize in the way he began talking about someone unprompted. To my surprise, this included Duke Johann Albrecht von Mecklenburg. The name needn't ring any bells. He briefly governed the Grand Duchy of Mecklenburg-Schwerin and was later elected regent of the Duchy of Braunschweig. He ruled over two very small states and was thus all the more vociferous in trumpeting his support for expanding the German colonial empire as far as possible. He was the honorary chairman of the German Fatherland Party, founded by Wolfgang Kapp, the putschist. I would never have anticipated Duke Johann Albrecht, says K., among the personages Pollak wished to remember, for either his sake or mine. The name had come up once before, though, when Pollak described bundling the letters from those dearest to him at year's end. He had mentioned Duke Johann Albrecht then, too. Pollak spoke of him with deference, indeed, with a devotion that seemed to have endured in memory for decades, the duke's views notwithstanding.

He was one of many who had come to Rome needing Pollak's help. Pollak called him his grand benefactor and, if he said so himself, a true friend. Pollak had even suggested to the duke, then serving as regent of Braunschweig, that he sponsor a stage production of *Goethe in Rome*, in Pollak's translation, at the court theater. But then came the war.

Following his nephew's abdication, the duke retreated to Wiligrad, a castle in the purlieus of Schwerin. Construction wasn't completed until '95. Johann Albrecht wanted Roman sculptures for castle and grounds alike, real sculptures from old Rome. The duke wanted to build a Rome of his own, Pollak said. Old Rome was surrounded by villas, the country estates of all those with clout in the capital. A country home styled after Roman villas, a villa with a garden full of sculptures from Rome. It was intended as an outward sign that a new Rome was emerging here. The duke needed help. That's why he came to me, said Pollak.

He got up again and walked past the table to the chest of drawers where the terra cotta portrait of him as a young man still lay. He opened one of the drawers, fished out a small purple box, lifted the lid, and placed the box on the table, its front side facing me. Nestled on purple velvet was a red-and-gold Cross of the Order of the Griffon on a glowing yellow ribbon. The silk lining of the lid was embossed with a golden closed crown along with a name I can't recall, but beneath it were the words *Grand Ducal Court Jeweler* and *Schwerin*.

The duke himself presented me with this, Pollak said, the pride in his voice undiminished. He and the duke had also spoken at length about the status Jews held in Prussia. He lifted the little purple box containing the medal with both hands. The duke had sounded like a liberal. Pollak actually said that, *like a liberal*. Then Pollak told me about a fourteen-day driving tour he had taken in the spring of 1906, just he and the ducal couple. He seemed even prouder of that

memory than of the medal. We required a pair of oxen to tow the vehicle up especially steep inclines, Pollak recalled. And then: I don't think they're coming for me.

He set the box on the table, returned to his seat, and stretched his back.

Since Mussolini fell from power, there has been a steady stream of rumors about what might happen to the Jews in Rome. The Jewish community is constantly being tipped off. I recall one warning in particular, said to have come through a Swiss middleman. Nothing happened. And what about the episode with the gold? Doesn't that grant us any protection? It would have been for naught, otherwise. Are you familiar with the story? Rather than detaining or deporting the Jews, Chief of Security Police Herbert Kappler issued an ultimatum that Jewish community leaders deliver fifty kilograms of gold within thirty-six hours; failing that, two hundred Jews would be deported to the east. Two hundred, not two thousand. Thanks to help from the Romans, the gold was handed over promptly. They got their gold and documented every last piece.

Did you know that the pope was prepared to provide the Jewish community with a loan, should there be any difficulty in procuring the sum? That he himself kept fifteen kilograms of gold on hand? Gold for the Jews. The pope is the defender of Roman Jews, said Pollak. All Roman Jews, he added. Not individuals.

He leaned back. His gaze lingered somewhere in the room. One hand rested in his lap, the other on one of the catalogues. It was the closest I had come yet to giving up.

Do you know Berenson? Bernard Berenson? Pollak went on. A fellow art dealer; his real name is Bernhard Valvrojenski. He once called me a "Shylock of pictures." He tried to explain why Jews always stay, despite how poorly they're treated. I cannot recall the exact phrasing, but as the story goes, on an excursion to the slopes of Etna, a man once marveled at the fertility of this exalted land, whereupon he was informed that the fields were regularly incinerated by lava flows. When asked why anyone would replant there, farmers responded that once things calmed, the fields were so prolific, it compensated for any and all disasters.

I used to think I was the only one for whom Rome held such significance, that it was my *terra benedetta* and mine alone. I eventually came to appreciate that Rome is not simply a city where archaeologists and dealers get more than their money's worth and art lovers experience heaven on earth, nor is it simply a city that shapes emperors, kings, and popes into the rulers they become. No, Rome is more than that. Rome is not simply a city; Rome is an idea, an emblem of greatness. It's why those who fancy themselves great wish to go down in history as the founders of Rome, the founders of a new Rome, the Rome of their age. For Hitler, though, not even that suffices. He wishes to be the greatest of all time. Of all time. You do realize that means of all time that has passed and of all time yet to come. Isn't that right? That is what he means, too. The truest, most extreme megalomania.

Mussolini hoped to be celebrated as a founder of a new Rome, too, which was why he began to reshape the city in

his own image. My museum fell victim to him. Mussolini has his Rome now, only he's been deposed, detained, and redeployed. What a ludicrous figure. *Sic transit gloria mundi.* That's part of Rome, too; it always has been. Isn't that right? It's not all *terra benedetta.* And now Hitler is building his Rome in Berlin. The greatest Rome with the greatest hall of all time, people say. It would explain why this Rome seems to be of so little importance to him.

In founding his Rome, Mussolini tore down whatever got in his way. Those who wish to found Rome must first wreak destruction. And when Rome itself gets in the way, it's Rome that needs destroying, that it may be founded anew.

It was Troy that had to fall before Aeneas could found Rome, the original Rome. The gods wanted Rome. They were consumed with the idea of seeing Aeneas found Rome, and for that reason, Troy had to fall. Achieving that aim took a decade of gruesome warfare, endless-seeming years of meaningless carnage. When a war lasts that long and so many families suffer, we ask ourselves why. Isn't that right? From time immemorial, we have asked: To what end? It wasn't military power that decided the outcome of that war, sealing Troy's disastrous fate, nor was it strategy or tactics. Only the horse could achieve what legions of young men, never again allowed their youth, failed to achieve with all their weapons and wiles.

Things are often different than we suspect, not least when the gods are involved. There's no telling with the gods. The entire ruse came within a hair's breadth of failing, because of

one man who threw his spear at the wooden horse concealing Greek warriors inside of it. A man who intuited that this gift did not bode well, who hoped to show, by launching his spear, what this horse truly was, namely a deadly weapon, a ruse ushering in their demise. The man who threw that spear was Laocoön, priest of Poseidon or possibly Apollo, according to Virgil. *I fear the Danaans, even those bearing gifts* are the words Virgil ascribes to Laocoön. Ever since, we have feared Greeks with gifts. The prophetic Cassandra was the only one beside Laocoön to warn the Trojans about the horse, but no one ever listened to her. By throwing his spear, Laocoön very nearly saved Troy and destroyed the idea of Rome before it even existed.

The entire time I was there, K. says, it surprised me that, beyond a few notably casual comments, the conversation had not turned to Laocoön. Now the name had been uttered. I considered interrupting Pollak and leaving his apartment without having accomplished a blessed thing.

SCREAMING is the natural expression of physical pain, Pollak said. Homer's injured warriors often fall screaming to the ground. Did you know that Homer doesn't mention Laocoön? I have spent a great deal of time thinking about Laocoön. Destiny saw to that. I have, however, also spent a great deal of time contemplating the notions of founding cities and destroying them. When Paris was slated to become the new Rome after Napoleon's victory over Italy, what, Pollak asked, did Napoleon have brought in from Rome and paraded through the streets of Paris?

It was lost in Paris, by the way, the right arm they'd made for Laocoön in 1523, out of terra cotta. French rulers as early as Francis I coveted the Laocoön group. Following the Battle of Marignano in 1515, King Francis demanded the pope hand over the sculpture. The pontiff dug in his heels. Francis had to settle for a bronze replica, which still stands in Napoleon's private apartment in Fontainebleau. Fontainebleau was yet another incipient Rome, the most radiant of royal residences, a villa surpassing all others, situated just outside the metropolis surpassing all others. It

was always meant to be Rome, or like Rome, after the latest fashion. Look.

Pollak did not need to get up to reach a picture frame lying unobtrusively atop a row of volumes on the shelf. As he pulled it out, a book that must have been resting on the frame slid onto the table. Pollak didn't notice. It was a slim paperback. The front cover read *Winckelmann's Collected Writings on the History of the Art of Antiquity, with Goethe's Comments on Winckelmann. Insel Publishing Co., Leipzig 1913*. The frame itself was simple, made of dark wood. There was no glass over the picture, which clearly wasn't an original.

K. reaches for the frame wrapped in brown paper, which lies beside the Remington between him and the monsignor. He unpacks it, revealing the image.

It vexed me, says K. At first I couldn't tell if the grainy quality might be due to its being a reproduction. I would describe the image as romantic. Monumental, too, though somehow nebulous. Perhaps those needn't be contradictory. I don't know much about these things. And I didn't recognize the work.

The image depicts a great hall of excessive proportions, far bigger than any hall ever built, with marble columns and a barrel vault. Glimmering beams of light, interrupted by a row of columns, fall on the scene from the right. The beams illuminate a monumental sculpture nevertheless dwarfed by the vast hall. People—spectators—are gathered round. They

are smaller than the sculpture at the center of it all. Their robes lend the scene a touch of color; the image is otherwise lost to beiges and browns, except where the sun streams in through the window, bathing the surfaces in a bright yellow that transitions to blazing white at the distant vanishing point. The sculpture is being hoisted by winch, clearly with tremendous effort, from the depths to the surface. It's Laocoön. The instant he emerges in the sunbeams' golden gleam, the painter fixes his movement in time, and with it, his story.

Pollak had turned the frame so I could see it easily, says K., doing the same for the monsignor.

The Finding of the Laocoön, the monsignor states.

Yes, Pollak said the same. He did not, however, mention the name of the painter.

It's by Hubert Robert, the monsignor tells K., before asking if he can identify where the French painter set the scene of the Laocoön group's recovery. It looks a little like Raphael's *School of Athens* in the Apostolic Palace, but is in fact the Grand Galerie at the Louvre.

K.'s expression does not betray whether he recognized it.

It is the famous scene from January of 1506, the monsignor explains, when Laocoön and his sons were borne from the cellar of a vineyard near the Colosseum. In reality, the sculpture group was broken, and the right arms were missing. All three. Painting, however, like every other form of art, enjoys its own reality. The tall man with the beard here

in the bottom right-hand corner is Michelangelo, continues the monsignor, who is clearly well-acquainted with the image. He is believed to have been sent by the Holy Father after news of the find reached the Vatican. You are absolutely right; there is something vexing about the sight, at least for those unfamiliar with the pictorial conventions of the late eighteenth and early nineteenth centuries, when this painting was created.

It was how people in the Romantic era imagined the moment the Laocoön group was discovered, Pollak told me. The Romantic era in France, he elaborated, a time in which Napoleon would emerge, the country would tear itself asunder, and the whole world would be overrun by wars. First the revolution, then Napoleon, then war, said Pollak. Laocoön extends his right arm heroically aloft. The arm is too long, by rather a significant amount in fact, if you look closely. And one is supposed to look closely at that very spot. We are supposed to see Laocoön straining his right arm upward, the gesture sublime, heroic. People at the time were convinced it couldn't have been otherwise; any other pose was unfathomable. People have always been fascinated, at once intrigued and intimidated, by the monumental. By that, and by destruction. Destruction is innate to the monumental, and because we know that, we can always see an element of destruction when admiring the monumental.

Back in 1506, they immediately knew what they'd found. They had encountered the Laocoön group in literature. Pliny describes the piece as exceptionally wrought. *Opus omnibus*

et picturae et statuariae artis preferendum, he writes. Scholars are at odds over how exactly to translate the line, but we can be certain of its approbation. The pope was alerted immediately. He is said to have dispatched Michelangelo along with the architect Giuliano Sangallo, both of whom confirmed it. Laocoön had reemerged.

He is illuminated in the painting as if he were a deity, though he was merely a priest. Do you know, asked Pollak, why the Laocoön group, the most famous of antique sculptures, a merciless and sensual portrayal of two serpents horrifically killing a priest and his sons—fine, perhaps one of the sons survives, but I don't believe that—why this piece has played such an important role for Rome and art and the world, or for the pope and Francis I and Napoleon and Mussolini? It's because they've always thought it concerned the founding of Rome and must therefore concern them. But that isn't true. In fact, it may not be at all true.

He interrupted himself, then began anew. There I sat, the battle as good as lost, and listened, at once captivated and exhausted by the tension, worry, and sustained helplessness. I forbade myself from looking at the window.

Standing before it in the Belvedere Courtyard—

Pollak trailed off, then adopted his now-familiar declamatory tone.

The first sight of a beautiful statue is, to him who has feeling, like the first view of the open sea, wherein our gaze loses itself.

Pollak did not divulge whom he was quoting this time, either. Felice de Fredis is buried in Santa Maria in Ara Coeli,

he went on. He found the Laocoön group. He was given a beautiful marble tomb just to the left of the altar. Translated, the epitaph reads, *In Honor of Felice de Fredis, who earned immortality through his virtue and service in discovering the divine statue of Laocoön, which nearly moves with breath where it stands on display in the Vatican.*

Nearly moves with breath. It rises above you, life-size, a pyramid of muscles. If you stare long enough, the marble begins to move. Its movement is slow, almost grotesque. You envisage it in silence, all the way to the bloodcurdling scream of the mortally wounded father—mute movements compelled by the deadly, writhing serpents. Artificial poses, typical of the late Hellenistic period, the focus on the main action, as if it were a painting or relief. Even in motion, down to the scream itself, the pyramid maintains its form.

The statue was broken and incomplete. It was reassembled and parts were added. Beyond the missing right arms, the snakes' heads had also snapped off. What we see today in the Vatican is not necessarily the Laocoön as it once was. It is our Laocoön, which may not be the one Pliny saw. Taking all details into consideration, one cannot even say for certain where the snakes' heads and tails were positioned—that is, where the serpents want to bite. Or have they already? *The snake has not yet bitten; it bites*, as Goethe writes.

Look Laocoön directly in the face the next time you go, and you will find ineffable pain. What you see in this reproduction of the French Romantic *The Finding of the Laocoön* is three outstretched arms, that of the father and those of

the sons. They are not, however, extended in pride but in a fight against death, to fend off the snakes. Their death is certain. Whether one is fighting death or fighting certain death makes all the difference. Is it noble? Pollak asked. Naive? Quiet? Grand? Or is it just terrible, plain and simple?

What a punishment. Just imagine: The Trojan Horse rolls into a city. A clever ruse. Isn't that right? Had it failed, the story would have turned out differently. Troy would have survived. Rome would not have been founded. And Laocoön and his sons would have lived. But it wasn't what the gods wanted. Athena, in particular, was adamant in her desire to see Rome built. The goddess wanted Aeneas to found it. This is why Virgil includes Laocoön's tale in the *Aeneid*, because it is central to Aeneas's destiny as the founder of Rome. Then along comes this priest. He senses something. We know that his intuition is correct, that this thing rolling into the Trojans' midst will be their downfall. That's literature. Only literature can accomplish that. Isn't that right? Neither the painter nor the sculptor has the means. It's a shift in perspective only the writer knows. We join Laocoön in the heart of Troy, within the city walls, when just moments before we were outside the gate with the horse. Now we are inside. And Laocoön throws his spear at the wood, angering Athena. It was her plan he nearly thwarted. One should never provoke the gods and goddesses. Theirs is a capricious fury. Athena sends the serpents to kill the priest Laocoön and his sons, the story goes—to kill the father and his two children.

The father and his two children, Pollak repeated. Revenge. Punishment. Atonement, he said next. Blame? The ruination of nearly an entire family, of a father and his two blameless children. Where is the mother?

The serpents, he resumed, are quick and aggressive in approach, stealthy in the killing. Once entangled, all hope is lost. Constrictors paralyze their prey, leaving it to suffocate slowly before they devour it, starting with the head.

I don't believe that's the real story, said Pollak. It is Virgil's account, but I don't believe it's the story that guided the sculptor trio of Hagesandros, Polydoros, and Athanadoros of Rhodes as they shaped marble into the silent, bloodcurdling scream that has rung in our ears for five hundred years now in the Belvedere Courtyard. I think it's a different story. After all, there is often another story, different than the one we tell because it's the one we were told and that is told and retold until eventually someone writes it down and others copy it—this, too, repeated ad infinitum—until this story is all that remains. It becomes the truth. I am certain Virgil's is the only tale you know.

Pollak began declaiming again, his tone solemn and delivery emphatic, if slightly affected. It was the passage in question from the *Aeneid*, and it was evident he's recited it many times. It's become second nature to him.

To K.'s surprise, the monsignor—who immediately knows the passage to which K. has alluded—begins to declaim the lines himself, by heart, in German.

A greater omen, and of worse portent,
Did our unwary minds with fear torment,
Concurring to produce the dire event.

When, dreadful to behold, from sea we spied
Two serpents, rank'd abreast, the seas divide,
And smoothly sweep along the swelling tide.

We fled amaz'd; their destin'd way they take,
And to Laocoön and his children make;
And first around the tender boys they wind,
Then with their sharpen'd fangs their limbs and bodies grind.

With both his hands he labors at the knots;
His holy fillets the blue venom blots;
His roaring fills the flitting air around.
Thus, when an ox receives a glancing wound,
He breaks his bands, the fatal altar flies,
And with loud bellowings breaks the yielding skies.

Amazement seizes all; the gen'ral cry
Proclaims Laocoön justly doom'd to die ...

Yes, says K., when he realizes the monsignor is not pausing
for effect, but has in fact finished his recitation. Yes, that is
precisely the passage Pollak quoted.

I abridged it somewhat, as you may have noticed, the

monsignor says. You should know that Laocoön has long been a source of great passion for me. Whenever I was in the Vatican for a longer spell—between assignments abroad, for instance—I devoted my time to Laocoön and his sons, to learn the group's history and keep abreast of current scholarship. I yearned to understand this one piece, if nothing else. But there are still so many unanswered questions. They are continually posed anew. I'm sure I've read everything ever written about Laocoön, including everything published in German—that especially. Pollak and I were in constant communication regarding Laocoön, with a primary focus on Winckelmann and then, again thanks to Pollak, with a shift to Goethe. You Germans have a much different perspective on Laocoön than we Italians. Goethe, Winckelmann, and Ludwig Pollak, the monsignor reflects, introduced me to Laocoön in German; indeed, they introduced me to the German Laocoön, which explains why I can recite those lines from the *Aeneid* as freely in German as in Latin or Italian. Since the threat to Roman Jews became evident, I have ensured that rooms were reserved for the Pollak family. He knows that. I have always made sure he knows.

Amazement seizes all... Pollak repeated that line after finishing the passage. How is it, he continued, that every era astounds by managing to produce greater atrocities than past eras? The question has confounded humans throughout history. Could we ever have anticipated this? he asked.

That wasn't right, though, Pollak said. The preceding silence lent the words an almost uncanny substance,

as if they were echoing in the immense hall depicted in the image that lay before us. That isn't the Laocoön shown here; it isn't the man with right arm outstretched, the way they pictured it, because it's how they—the pope, Lessing, Winckelmann, even Goethe—preferred it. They weren't mistaken. No, this was no mistake. They were willfully misled. That's the right expression. And that's something different altogether.

He was declaiming again. This time I recognized the passage. Before visiting Pollak, I had read it in a catalogue I brought with me to Rome. This time I knew it was Goethe.

K. is surprised as the monsignor again holds forth:

In order to experience this sense of movement in the Laocoön group, I would suggest that you face the sculpture from a proper distance, eyes closed. If you open and then immediately close your eyes, you can see the whole marble in motion, and you will even expect the whole group to have changed its position before you glance at it a second time. I would describe the sculpture as a frozen lightning bolt, a wave petrified at the very instant it is about to break upon the shore. The effect is the same if the group is viewed at night by torchlight.

Yet again, the monsignor has recalled the correct passage.

Pollak has always been haunted, he told me, by the fact that even Goethe—the wisest of all, he called him—failed to see it. Then again, he didn't know about the arm, said Pollak.

No one knew about the arm, including me. Until it was right there in front of me, that is.

Not one of them wrote about what they saw; instead, they wrote about what they thought. And when a man thinks long enough about what he wants, it eventually becomes what he sees. At the very latest by the time he records these thoughts, maybe even publishing them, they become what everyone else sees as well. That is the essence of literature, which follows very different laws than the visual arts. Luckily for them, the right arm had snapped off, snapped off and vanished. Many antique statues are missing the right arm, which is usually the most exposed feature, positioned as it is to express the meaning of the sculpture. The right arm has the final say, particularly when it comes to Laocoön. Not on life and death, as Laocoön's death is assured. How he confronts the serpent, though, what it does to him, and he to it, is all determined by the right arm. In other words, it decides whether the doomed fellow remains a hero in the end or was never a hero to begin with, but was a mere human all along, perhaps even a pitiful one at that, a victim.

The right arm holds the truth. Farfetched as it may sound, that is the case, which is why it was so rousing a moment to see it simply lying there among other marble scraps. I immediately knew it was the arm of Laocoön. Had I not happened to be passing by, there's a good chance the arm would have disappeared once more, never to trouble the world of art and art history. But because I spotted it, said Pollak, there it is: Pollak's arm.

IT WAS ON VIA LABICANA, on the Esquiline Hill, just a few hundred meters from where they had unearthed the sculpture group in 1506. The stonecutter told me the arm had just been found on Via Labicana and delivered to him, but provided no further details about its provenance. A muscular right arm made of marble with pronounced biceps. The arm of a male athlete—a dying athlete, I immediately recognized. A protuberance above the biceps. I knew at once that it was part of the deadly serpent gliding across the smooth arm. I bought the arm on the spot to protect it from certain ruin. Thus it returned to the world. The true right arm of Laocoön was back, but it wasn't extended in exultation; no, the arm is bent, almost twisted. This hero is no hero. That isn't my fault. I didn't chisel the arm. All I did was find it. And recognize it.

Among my first coups as an art dealer were several pieces I brokered for the Dresden Sculpture Collection. To transport the bigger vases in the deal, I disassembled them into their constituent fragments and later reconstructed them. I mention it to help you understand that I was better trained in

handling fragments than any other. I also bring it up because Winckelmann wrote his famous text about the Laocoön group in Dresden, not Rome. Noble simplicity, quiet grandeur. Winckelmann was looking at a small copy when he wrote that.

The Laocoön group is a colossal, immense work from which howls a violent, superhuman agony, reverberating inside anyone who comes to stand, however unwittingly, in its presence. And then there's Winckelmann, studying a diminutive replica that sits on his desktop in Dresden. Different ideas occur to you there. Had he been in the Belvedere Courtyard, noble simplicity wouldn't have suggested itself, much less quiet grandeur. In their own way, such notions may well pertain to grandeur, but they will forever remain notions that emerge from the study of small replicas. This is not the idea of Laocoön; it's Winckelmann's. He wrote it down, everyone read it and liked it so much, they said, yes, that must be right. And so it has been ever since. We've held onto this idea ever since, as though it were the truth. No sooner do we walk up to an antique sculpture, than we think, *Noble simplicity! Quiet grandeur!*—

Just as the depths of the sea remain placid, turbulent though its surface may be, so the aspect of ancient Greek figures, however seized by passions, evince a grand and staid soul.

There is another line of Winckelmann's, however, to which I return most often, said Pollak.

Laocoön suffers, but he suffers like the Philoctetes of Sophocles: his pain pierces our souls, but we covet the hero's strength to endure such misery.

According to Winckelmann, Laocoön isn't screaming; he's sighing. But we do not sigh in the face of true misery. We scream. And *that* is Laocoön.

I was both impressed and overwhelmed by this unexpected outburst, says K. I sat there listening to the old man fling one truth about Laocoön after another from his armchair, as if he himself were an ancient deity or one of the Renaissance popes who sat for portraits upon ornate thrones. Doesn't a portrait like that exist of Julius II, the pope who had the Laocoön group installed in the Belvedere?

The monsignor nods, adding that it was the same Julius II for whom Raphael painted *The School of Athens*, the fresco that Hubert Robert's painting recalled.

Pollak spoke about Julius as well, says K.

They discovered the Laocoön just as the Vatican leadership had undertaken to found a new Rome in the spirit of the old. Pope Innocent VIII commissioned the first structure in the style of this new Rome, a grand palace, the Villa Belvedere in the Vatican, the first Roman villa of the Renaissance, and his successor Pope Julius II had Bramante draw up the Belvedere Courtyard. It is there of all places that the Laocoön appears, albeit without the right arm. Pope Julius immediately recognized the significance of the treasure that had fallen into his hands, or rather—Pollak apologized for the expression—that he had snatched. Julius paired Laocoön up with Apollo, at which point he could say, see, I really have founded Rome anew, just as I am the new Julius, the Caesar of Rome and the world.

Pollak rested his right hand on Hubert Robert's *The Finding of the Laocoön.*

Starting in the Renaissance, they danced about Laocoön and his sons as if they were the golden calf, then Winckelmann, Lessing, and Goethe followed suit. The sculpture group was at times concealed inside a wooden shed. Did you know that? Too much nudity for the Vatican. It was lucky that the Laocoön went practically unseen for so many years, however, in the same way it was lucky that the right arm was missing. It allowed everyone to cast the figure and the arm and the image of Laocoön in whatever light they preferred. After they boarded him up, it was a suffering Christ they chose to see in Laocoön. But I ask you: Would the idea of Noble Simplicity and Quiet Grandeur have occurred to Winckelmann at the sight of Jesus on the cross? The attempt was made, though. There's an ivory crucifix—there are three, in fact, three versions—by the Baroque sculptor Georg Patel, who modeled Christ's features after Laocoön. There is little one cannot do with Laocoön. Laocoön and his sons. It isn't a sculpture. Like Rome, it is an idea. And the right arm, *my* arm, destroyed that idea.

Pope Julius died before his Belvedere was completed, as did the architect, Bramante. By that point, however, Laocoön was whole again, at least in their eyes. They had enlisted the great artists of the time to manufacture replacements for the parts that had broken off, the serpents' heads, the three right arms. They chiseled new arms. And what does man do with the right arm? Why, he extends it heroically skyward. They

could not conceive of someone commissioning an enormous sculpture of a strong and handsome man who, it ultimately turns out, isn't even a hero.

To find is one thing, to recognize is another. I immediately saw that it had to be the arm of Laocoön. Now they call it Pollak's arm. That is how I will be remembered by posterity, as a broken arm. Perhaps someone should write a history of mankind as the history of right arms.

I was permitted to examine the sculpture closely in the presence of Bartolomeo Nogara, the director general of the Pontifical Museums, the man who later helped me when no one else would. I climbed up and touched the precious form with my own hands, the cold, smooth marble. An inconceivable, nearly indescribable feeling of transcendence for someone like me. So much for *ex uno lapide.* That was what had always been said, namely that the sculpture group had been chiseled from a single block of marble. It only appears that way. They hid the joints behind the coils of the serpents. Creating the illusion of its having been made from one piece may, in fact, bespeak a much greater virtuosity. I discerned that the right arm had already broken off and been remounted in antiquity. On the backside of the pedestal, I also espied one of the arms created during the Renaissance, with two snakes twined about it. A grotesque sight. The backside of the pedestal is a good place for that arm.

For an entire year I kept it at home, in my bedroom. I spent a year with the arm, not entirely sure how to proceed

and also reluctant to be separated from it so soon. I could already tell that this marble fragment—which at the time no one knew existed, except me—would throw the world out of kilter. I did show it to a select few, Nogara first, naturally. And then one day, the time had finally come; I couldn't tell you why it happened on that particular day, what compelled me, but I took the arm, hoisted it onto my shoulder, and carried it straight across the old city to the Vatican. It grew heavy along the way. The curators at the Vatican, who were not yet aware of the arm, were more than a little surprised.

I am trying, says K., to imagine Pollak marching clear across the center of Rome shouldering a marble arm. He must have turned heads. Did he take the Corso Vittorio Emanuele? Or perhaps the route past the Spanish Steps and across the Ponte Cavour?

I did not publish on the arm until three years later, in 1906. It was the year of the big celebration, the four hundredth anniversary of the discovery of the Laocoön group. Just a few pages, titled simply *The Right Arm of Laocoön*. I was besieged by journalists following its release. They asked why I donated the arm to the Vatican. What alternative was there, I countered. Haggling over a price? For a piece that so plainly and patently belonged where it belonged? That wouldn't be art dealing; it would be extortion. That was my response. Being a dealer means finding the right person for a piece, or searching out the right piece for a person. I was always a dealer. They left me no other option.

Back then the German Archaeological Institute hosted lectures every other Saturday between Winckelmann's birthday on December 9 and the anniversary of Rome's founding, April 21. I delivered a presentation on Laocoön's arm at one of them. Full members of the institute sat around the table, corresponding members behind them, with all other attendees filling the space beyond. The atmosphere was pleasant and familiar, nothing like the artificially stoked antagonism that would later run rampant, poisoning things ever since. One was accepted for who he was. There were no questions about birthplace or heritage.

I was made a member of the German Archaeological Institute and Commander of the Order of Saint Gregory the Great. Without any action on my part, the arm caused a real stir, especially in Germany. We even had correspondents come to our apartment and demand photographs of the restored group. At that point, not even I had seen the photos. And to this day, they haven't reattached the arm.

The arm was thus returned to Laocoön's shoulder, however briefly. It was at once uplifting and disappointing. I knew that what I had found, while unquestionably the real arm of Laocoön, did not belong to the piece in the Vatican. While studying the statue, I ascertained that the arm is too small. Not by much, but it is too small. The surface of the marble is also different, as is the color. The arm I found must therefore belong to a copy smaller by one ninth, to be precise. The sting of disappointment is never greater than when it punctures euphoria. It is, at least, a contemporary copy.

That much is certain. And the message the arm conveys is no different in a copy than in the original, which has yet to be found, mind you. For people like me, though, originals have an aura that even the best, oldest, most exquisite copies will simply never match.

Laocoön's face is anguish incarnate. One can understand why Vatican priests of the Counter-Reformation would see the suffering of Christ in it. The body strained to its breaking point, the visage distorted. It's the image of someone in supreme pain, rearing himself up against destiny. There is no standing up to destiny, though.

We don't even know which Laocoön is being referenced, which version of the Laocoön story the sculpture is telling us. Another version does exist, you know, one far less heroic. It is simpler and more human and true. I am convinced that it's the tale the three sculptors from Rhodes had in mind as they chiseled, and it is this Laocoön they carved from stone—not Virgil's.

According to this story, the serpents were sent after Laocoön because he fornicated with his wife on the altar. As a priest, he should not have sired any children. Though the gods pardoned that transgression, his desecration of the altar was different. It meant death for him and his sons. A gruesome death, a disgraceful end for a priest. Meaningless, not heroic. Hence the angled arm. The snake has long since won. The harrowed face shows the suffering of a condemned blasphemer, not the struggle of a courageous hero. Viewers are meant to delight in this hideous ordeal, or perhaps be

frightened by it. But he's no hero, and neither nobility nor grandeur is on display. Simplicity, maybe. And a bloodcurdling scream ringing in the silence.

Though the arm may be a copy, that is the story of Laocoön. The extended arm is monumental, sublime, and wrong. The arm that will never reach out again. My arm—the arm of a doomed man—that is the real arm.

Pollak's gaze wandered over to the window and mine followed. If there was any hope of avoiding the danger of getting caught in the dark, I had to leave, even if it meant without the Pollaks. All I could see out the window was the approaching darkness, whereas he seemed to be thinking about the city itself as it darkened.

Rome has long since succumbed to the sea serpents, he said. They are unpredictable. They will strangle one man until he can no longer breathe, while biting the other and relishing in his ruin. Surely it's much safer for us not to go out, to simply stay here. What could they possibly want from an old man like me? But the snake always wins. Laocoön teaches us that. Man will never win against serpents sent by the gods. Not in this world.

HE TURNED and looked me straight in the eye. One must give a personal account, he said. Particularly when the end is imminent. One must tell stories. One must write them down. One must ensure that memory remains, so that others might remember when you no longer can. Otherwise, you'll be forgotten, along with everything that was ever important to you, and it will all have been in vain. It's why I've always kept a diary. Things age differently when one keeps a diary. There's the event and how it really happened, though its colors fade with each passing year. The diary, however, also preserves the moment of writing about the event. That is where memory starts.

Mussolini's arrival in Rome. That was a day to remember. My memory of that day opens with the image of me sitting at a table, writing. It was October of '22. Morning. Mussolini welcomed like a king, I wrote. Shops all closed, streets full of singing fascists. Then the fraternization between fascists and nationalists. Mussolini's appointment as prime minister. Parades and demonstrations across the city. Nationalists in blue shirts on the Spanish Steps, everything full. The images

are stored in my diary; it's why they remain so vivid in my mind.

I was introduced to Mussolini once while attending a function at the Czechoslovak Embassy. This, too, is in my diary. He found a few approving things to say about my newly published catalogue of Italian bronzes in the Barsanti collection. His head was Napoleonic, his stature rather diminutive. Strange eyes. Terrible, really. One could see how ill at ease he was in present company.

November of '23, Hitler's putsch in Munich, the day before the coup. I recorded this in my diary as well and have thought of it daily in recent years. Hitler has toppled the government. Civil war has broken out. God only knows what will come of it! I wrote, with an exclamation mark. I've noticed while rereading that I began to use exclamation marks liberally at that time, far more than in the past. I have something of a quirk when writing, whether a letter or diary entry. I place a period, followed by a long dash, at the end of each thought.— Rarely exclamation marks, though, until then. The exclamation mark displaced that combination of period and dash. Meanwhile, the exclamation mark is itself a combination of period and dash—except the latter is vertical not horizontal. When I read my diary now and notice a period paired with a horizontal dash, I think: That is a transition to something new. An exclamation mark is always an ending.

He rose and went into the next room, again bracing himself on the doorjamb. He returned with three books, all slim

and cloth-bound with marbled cardboard covers, though slightly different in dimension and color. He sat back down, produced his glasses from their case, and drew the top book from the pile toward him. Several loose sheets protruded from the volume, which he seemed to open at random. Then he reached for the second in the pile. I spotted a bookplate on the inside cover, *Ex libris Ludovici Pollak*, bordered in flowers with little *putti* on either side, one holding an open book, the other an antique sculpture. Pollak turned the pages. I could make out dynamic handwriting with spirited strokes upward and downward. On the unruled paper, the lines tended upward at the end.

August of '29. Pollak pointed at the page he had reached. My wife and I were in Zurich for the Zionist Congress. He put on his glasses. Expressions of great solemnity, he read, as well as fanaticism on people's faces. The Jewish Agency is concurrently holding its inaugural convention in the city. The first time in two thousand years that Jews from around the world have congregated; truly a historic date, he read. He looked up. We failed to procure tickets for the session in the Tonhalle. The next day, however, he continued reading, we were granted entry. Stunning sight. Jews from around the world, Chaim Weizmann and Louis Marshall presiding. Closing session in the Tonhalle. Representatives of various nations signed the resolutions, prompting terrific jubilation.

The Jewish Agency suffered a terrible blow the very same month, Pollak read. A horrific massacre of Jews in Palestine committed by Arabs, nearly five hundred Jews slaughtered.

Strange start for the newly founded agency. It was like a commentary on the Druze massacre of Christians in Damascus in the sixties. And on the weakness of the British government. Even back then, Pollak added.

Then the violence worsened. There were the murders perpetrated by Hitlerites. Like Chancellor Dollfuss being assassinated by Nazis in Vienna. International outcry against a Hitlerite Germany that had paid the killers, but what was the use?

He paged through one of the diaries. Hindenburg's death. One cannot help but to feel, he read, that the last vestiges of old Germany have passed away with him. Hitler grants himself the presidency. Anything is possible these days.

Hitler wrote down what he thinks, you know. And I read it. I have read *Mein Kampf* from cover to cover. Hitler's hatred of Judaism is pathological. Jews are to blame for everything. And suddenly I became—no, it wasn't sudden, the change crept in gradually. Over time I became more Jewish, to a degree I never had been in younger years. Early on, there was the shadow of the Prague ghetto. My parents were assiduous in their efforts to leave it behind, and I followed suit. I was fortunate to receive a German education, then I came to Rome. And now the ghetto returns.

My antidote was reading—Franz Werfel, Egon Erwin Kisch, Joseph Roth, Jakob Wassermann, Lion Feuchtwanger, Gustav Meyrink. Exclusively Jewish writers. *Job*, such an affecting book, and with such simple prose. Then Joseph Delmont's *Jews in Chains*, a story set in tsarist Russia. *The*

Wandering Jew Has Arrived, by Albert Londres, a distressing work. Suddenly these were all books about me. Kafka, Feuchtwanger's *The Oppermanns*, Michael Gold's *Jews Without Money*. I read historical accounts, too, of Jews in Austria, Russia, and Rome. Then I myself began to document personal memories: childhood, Prague, the ghetto, Rome, the great wide world. Ludwig Curtius had long urged me to write about my life, saying it would be a boon to archaeologists, art dealers, and collectors, one that would otherwise be lost. The title was already decided: *Memoirs of a Roman Collector and Art Lover*.

I started writing in the summer of '33, already under the aegis of Hitler. When you start documenting your life in '33, you do not open with the Roman collections; you open with gloomy little rooms in the Prague ghetto. I wrote page after page, rereading Werfel and Meyrink to remind me of what things were like back then in old Austria. It seemed an eternity had passed since then. One forgets so quickly. Isn't that right? If and when images do return, it is typically in congress with others. Or while reading your diary.

When I sat back down on November 9, 1933, I neatly crossed out well nigh everything I'd written. I remember the date. The title had changed. *Cum ira et cum studio: A General Reckoning with my Opponents*.

In recent years, marked by so many dark days, I have become friends with the chief rabbi of Rome. His name is David Prato. We discuss the history of Judaism a great deal, and there is much I have come to understand. I changed over

time, in my own estimation as well as others'. When I met with old acquaintances, an increasingly rare occurrence as it was, things were different than in the past. His Excellency Diego von Bergen, for instance, the German ambassador to the Holy See. We used to meet frequently and converse at length, always respectfully. From one day to the next, von Bergen's demeanor toward me stiffened. He wasn't the only one, of course, but he's always first to come to mind when I reflect on my gradual disappearance from Rome, the way my presence was no longer acknowledged among the buildings and on the street and in the *piazze*. They no longer mentioned me in books, either. All for fear of the Hitlerites. Extinguished. It's quite simple, really.

Italians are not fanatics. It was another reason I always considered Rome *terra benedetta*. I couldn't imagine people here becoming anti-Semites, fanatical haters like the Germans. Mussolini is different—or at least he was. Do you remember what Mussolini said after the Hitlerites killed Dollfuss?

In '32 I met the renowned biographer Emil Ludwig at a reception and subsequently read his interviews with Mussolini. A truly splendid work. It redounds to both men's honor. The book gave me a wholly different sense of Mussolini. He sharply criticized the persecution of Jews in Germany. And yet. It all started with the articles against Zionists. Over time Mussolini edged closer and closer to Germany. And now his Rome is in German hands.

And finally, the manifesto. The *manifesto del razzismo italiano*. 1938. *Paragraph one. Human races exist. Paragraph*

two. There are great races and low races. Paragraph six. There now exists a pure Italian race. The time has come for Italians to openly declare themselves racist. Paragraph nine. Jews are not part of the Italian race.

By then I was left with just one official function, that of honorary curator of the Museo Barracco. They didn't strip me of my role. They took the museum itself.

Pollak reached for one of the diaries and flipped through. Here, he said, turning the book, its pages densely filled with script, so I could easily read the entry.

Littered with exclamation marks, as you can see. April 1933, a Hitler rally at the Hertziana Library. Can you imagine? The Hertziana, of all places. I used more exclamation marks during those weeks and months than usual, two, three, sometimes even four in a row, like the asterisks indicating tourist attractions in a Baedeker. The more horrific, the more inconceivable, the more exclamation marks. Here, look. Göring was here for Hitler's birthday. Göring. Exclamation mark. In the Hertziana. Exclamation mark. Founded by Henriette Hertz, a Jew. Four exclamation marks. The swastika flag hung above the entrance, alongside the flags of imperial Germany and Italy. Two exclamation marks. Hung from the building Fräulein Hertz and Frau Mond donated to the Kaiser Wilhelm Society. Exclamation mark. The irony of world history. Exclamation mark. An embittering development. Exclamation mark.

The name *Hertziana* was abolished in '40. It is now known as the *German Cultural Institute of the Kaiser Wilhelm Society in Palazzo Zuccari.*

Pollak's words were thick with contempt, though his voice was growing weaker.

The bust of the magnanimous founder disappeared from its niche. This Henriette Hertz reminded me in many ways of her nominal double in Berlin, the celebrated Henriette Herz, who was friends with the writer Ludwig Börne and the cultural patron Rahel Varnhagen. Our local Fräulein Hertz also fell victim to the philanthropic Roman illness of collecting. That is what I've always called it. She transformed Palazzo Zuccari into a museum in no time at all. Among the antiques are several fine Roman portraits from Imperial Rome—a bronze portrait of Caligula, for instance—but most significantly, a head known in the archaeological literature as Hertz's head, which is of utmost historical importance. Hertz's head and Pollak's arm—it's how we Jews have entrenched ourselves in Roman archaeology.

K. pauses. I've had a nagging thought this entire time—

The monsignor furrows his brow and looks up, his interest piqued. His eyes encourage K. to please, by all means, share this thought.

Doesn't the appearance of this other arm—Pollak's arm—have obvious consequences, yes, for our understanding of the statue of Laocoön, but also for the image we have of antiquity and our own ideals? And aren't these consequences far more radical—or, rather, wouldn't these consequences *have to be* far more radical than any of the corrections that have since been made to this image? And isn't there a chance

this would all be different, had the arm been found by a professor, not an art dealer, and had that man not been Jewish—

The monsignor's expression darkens, while the furrows remain. He does not respond to K.'s observation. K. himself does not pursue the thought, but returns to his story, to Pollak's story about Henriette Hertz.

In the final years of her life—she was only sixty-six when she died in 1913—Fräulein Hertz enlisted her friend Professor Ernst Steinmann to create an art history library on the first floor of the palazzo. The Hertziana provided a missing piece in the Roman library system. In her will, Henriette Hertz bequeathed her paintings to the city of Rome and the palazzo, complete with library, to the Kaiser Wilhelm Society in Berlin.

Without warning, Steinmann was later ousted from his position as director of the Hertziana by one Doctor Hoppenstedt. Then Steinmann died. It was the politics in Germany that killed him, Pollak said quietly and more gently, but decisively. Steinmann's ashes were interred in a small, antique Roman urn between his wife, Olga, and dear friend Henriette Hertz at the cemetery by the Pyramid of Cestius. Steinmann had been delighted when, at his request, I verified the marble urn's historical significance.

His voice faltered.

I was the first and most faithful visitor the Hertziana ever had. And then—

Rather than complete the sentence, Pollak pulled out three sheets of paper protruding from one of the diaries. I

couldn't immediately discern if they were typed notices or carbon copies.

Look here, said Pollak. I'd like to read you something. His voice now threatened to fail him completely. Three letters, he murmured. There may have been tears. Two addressed to me, one from me; I saved the carbons.

He put his glasses back on. The onion skin trembled in his hands as he began reading, almost inaudibly. The first letter, he said, is dated April 5, 1935.

Dear Doctor Pollak,

It has come to our attention, this time from direct sources, that your efforts to defame the Bibliotheca Hertziana continue unabated. You are reported to have said that Steinmann died of a broken heart, because an unwelcome successor was forced upon him.

I'd initially thought he might find it easier to read from the page than recount things in his own words, but it soon became clear that he was far too agitated or too sad or simply too tired to read the text, the conclusion of which he knew all too well.

Given your outsize interest in the precise details of all Roman personnel concerns and how this case, in particular, unfolded— viz., that I agreed to come to Rome solely in response to my friend Steinmann, who had repeatedly implored me to become his successor—I must conclude that this behavior of yours

amounts to nothing less than a deliberate attempt to malign me and the institute entrusted to my care. Meanwhile, not only do you continue to avail yourself of the hospitality our institute offers, you also address me in genial terms whenever we meet.

His voice now failed entirely. Please, he croaked weakly, read it yourself. He handed me the pages, the letter he'd begun reading to me on top. I read.

I neither know what may have inspired your animosity toward me, nor do I particularly care. Surely you understand that, in response to these incidents, I must request that you refrain from entering our premises. Rest assured, I will see to it that the details of your behavior are made known throughout local German and Italian circles.

(sgd.) L. Bruhns

Dear Professor,

Lübeck City Hall bears the inscription 'One man's word is worth no man's word—both should be heard.' As you have failed to do so, I wish to share the following:

1.) It is true that I said Steinmann died of a broken heart. This opinion is, however, shared by many, both here and elsewhere.

2.) It is untrue that I am supposed to have said you were forced upon him as a successor. In discussing Steinmann's death, I never uttered your name in the manner you aver. Instead, I

consistently asserted that your appointment (the background to which I am only just learning from you—as it is, I did not learn of Steinmann's illness until November, etc.) represented a glimmer of hope for the reshaping of the Hertziana, as yours is an estimable, noble character that all friends of the Hertziana must congratulate on having become Steinmann's successor.

3.) Whoever led you to believe the opposite was lying, turning things around. Whether this despicable individual did so out of malice, ignorance, misunderstanding, or for another reason altogether, is beyond me. If I knew who it was, I could draw my own conclusions.

I have never had, nor do I have the least reason to feel animosity toward you. I have only twice or thrice had the opportunity to exchange a few words with you, these encounters always extremely brief, and on the morning of the day before yesterday, just hours before receiving your letter, I was preparing to send you a short booklet of mine. Is this something one does for his so-called enemies?

Your excommunication of me from the Hertziana and Palazzo Zuccari, which I have frequented for nearly 35 years— to the benefit of many, I might add—is duly noted. It comes as no surprise whatsoever. On the contrary, I feel privileged to have avoided summary banishment and been frozen out peu à peu instead, which was no doubt thanks only to my advanced age of 67 years. You are, in fact, doing me a service, as my occasional recent visits were carried out by force of habit, despite the marked change in atmosphere that has prevailed thereat for two years now.

You do me a further service by seeing to it, as you have threatened in writing, that certain German and Italian circles learn of my behavior. I am Czechoslovak, not German, and thus indifferent to what some German circles here think of me. Influential Italian circles, meanwhile, will hear from my children—themselves fervidly Italian, naturalized, born in Rome some 25–35 years ago—and me about how a man of advanced years, a reputable scholar and oldest friend of the Hertziana, has been treated in response to baseless rumors, spread without any attempt made at ascertaining the truth, primarily to satisfy the wishes of some of the library's younger representatives, who have themselves enjoyed many a cordial encounter with me.

(sgd.) Dr. Ludwig Pollak

Dear Doctor Pollak,

In response to your letter from the 8th of this month, which I have just received, I have only the following to say: It is absolutely preposterous to suggest that, for years, those in the employ of the Biblioteca Hertziana have attempted to, as you describe it, freeze you out. Now as ever, we grant access to our library to art lovers and researchers alike, irrespective of nation or race; nevertheless, we are resolved to defend ourselves against such slander as has been relayed to us through countless channels.

Duly noted that, when discussing the successor responsible for Steinmann's broken heart, you did not mean me, though I feel it incumbent on me to note that my colleague, the director of the other department, bears as little blame for this heartbreak as I. Might I refer you to Steinmann's will, composed a mere week

before his death, in which the deceased also made a bequest to Doctor Hoppenstedt, thus denoting their friendship in rather spontaneous fashion.

I would hereby like to terminate this unedifying debate once and for all, but remind you that I am prepared to take any action necessary against these incessant, vile rumors that cause such damage to the Bibliotheca Hertziana.

(sgd.) Bruhns

Will others be rounded up after me, or in my stead, if I do not come with you? Pollak asked quietly, the moment I lifted my head after finishing the last of the three letters.

I had no authority to answer the question, nor would I have had a response.

Mustn't we accept the fate assigned us? he asked.

Still I remained silent; I didn't know what to say.

Even when it's the fate of an entire people, of one's own people.

I knew then that I had lost him.

Nevertheless, I made another cautious attempt, my own voice lowered. Mustn't one save his life—his own and the lives of those in his care—if the opportunity presents itself?

It was my final stand. It felt as though the ground were giving way.

What possible path could God have intended for us? Pollak said, and then: They're not coming, though. Not tomorrow.

K.'S FACE appears sunken. Beside the Remington and pile of blank typewriter paper on the desk is the reproduction of Hubert Robert's *The Finding of the Laocoön*, as well as the three letters K. read the previous evening in Palazzo Odescalchi and that Monsignor F. just finished reviewing. Pollak insisted that K. take them. The monsignor asks if he might keep the missives to share with Director Nogara and the cardinal.

I had already stood up, K. recalls, as had Pollak, when he handed me the frame, followed by the letters. He asked that I please take them with me. I didn't ask why or for whom; I simply took the papers and frame and said goodbye—I can't even recall the words I spoke—and left the apartment. I found the car and driver right away. We drove fast. It was not yet as dark as it'd appeared from inside the apartment. I pray that I will one day forget the feelings that seized me on that drive through Rome, the city ghostly quiet and already robbed of color. It wasn't a Mercedes, by the way.

I rushed to my quarters upon reaching the Vatican and lay down without undressing. Sleep was an impossibility. I

got up and started looking through the books I have access to here for some of the passages Pollak had quoted. Then I returned to bed. The conversation and all its particulars kept running through my mind. I relived it over and over, again and again. I couldn't stop following its many forks and leaps, an endless loop that outran all other thoughts and returned to the beginning with a renewed sense of hope every time it reached the end.

I couldn't tell you how the hours were spent. I must have fallen asleep at some point. Caught somewhere between sleep and trance, I was as unaware of night giving way to morning as I was of time passing today, this fateful day, until you sent for me in the afternoon. I was repeatedly startled awake by brief, dark dreams. Then the memories returned. I woke up screaming at one point, convinced I was paralyzed. My arms and legs had fallen asleep. When you sent for me, I got dressed, grabbed the letters and picture frame, and came straight here.

The monsignor proves well informed—surprisingly so, K. finds—about what has happened, and is still happening, in Rome that day. Dannecker intentionally scheduled the raid on the Sabbath, the monsignor explains. He led the charge himself. First, SS police units silently advanced and surrounded the ghetto. The raid itself began at about 5:30 a.m. The ghetto was cordoned off and the streets were combed, one after another. No allowances were made, whether for mothers with newborns, children, the infirm, or the elderly. At the same time, arrests were being made

citywide. These squads drove around Rome until midday, working their way down Dannecker's list, address by address. The raid was declared complete by about two this afternoon. More than a thousand people have been detained. They're saying Dannecker is dissatisfied because he'd promised more. The people were herded toward the Theater of Marcellus, where a collection point has been set up. From there, the captives are apparently being trucked across the Tiber to the Collegio Militare. What will happen to them next is unclear.

K. does not ask where the monsignor got this information, nor does he ask if there was any effort by the pope to intervene. Even without K.'s asking, however, the monsignor explains that earlier attempts were made to prevent the raid. When General Stahel, commandant of Rome, was informed of the arrival of the SS commando tasked to prepare for the job, he allegedly sounded out the German ambassador to the Vatican, Ernst von Weizsäcker, for diplomatic assistance. Apparently an officer from his staff was sent to deliver a written appeal to Weizsäcker, requesting that the diplomat engage the Foreign Office in undertaking action against the planned raid. Weizsäcker waved it off, saying there was nothing he could do.

An overpowering silence takes hold of the room. The monsignor places the letters he just read beside the picture, the pages meticulously aligned, with the carbon of Pollak's response resting on top. He slides the wooden frame closer and eyes *The Finding of the Laocoön*.

Pollak insisted that I not only take the letters, but the picture as well, K. repeats.

The monsignor leans forward and cocks his head. He lifts the frame and turns it carefully this way and that, appearing less interested in the reproduction than in the fine line along the inside of the molding, where the picture meets the frame. He plucks a letter opener from the worn leather cup by the typewriter and positions it in the upper left-hand corner of the frame. He runs it along the inside of the molding, first to the right, then down, back to the left, and up again. The spirited motion is accompanied by the quiet hiss of tearing paper. The monsignor gingerly removes the Hubert Robert reproduction. He clearly saw, or simply suspected, that there was something underneath. It's another reproduction. The image is deeply disturbing.

Three gaunt nudes lie on the ground outside an old city, their bodies unnaturally contorted beneath vaulted, apocalyptic heavens. Sky and bodies are robbed of color, caught in shadows, the clouds bluish, the pallid human forms tinged with purple. There is no structure, nothing is balanced, no focal point, no perspective, no harmony. Everything seems ruined, even the color. Any remaining hints of brown, yellow, or green ultimately appear gray. One might think at first what was being depicted were bizarre gymnastic exercises. But the hoop one of the figures, a boy, holds in his hands turns out to be a writhing snake. Another slithers on the ground. A second boy appears already to have died. At center

lies an old man around whom everything else is arranged, and who will presently be bitten in the head by the snake moving across the ground. To the right stand a man and woman, also nude, watching the grisly scene as though it were entertainment.

El Greco, the monsignor says. El Greco's *Laocoön*. Odd painter, and it's his only piece portraying ancient myth. Of all scenes, he chooses one as important to the Renaissance as Laocoön's death. El Greco, the monsignor tells K., was in Rome, which means he saw the Laocoön. He may have chosen this particular subject deliberately as a repudiation of the Renaissance, in that he destroys the consummate harmony of the Laocoön group, dismantling its architecture, subverting it. Instead, he revels in chaos on the very site once governed by perfect harmony. Do you see the horse trotting toward the city wall in the background? Perhaps it's the Trojan Horse, says the monsignor. The city portrayed is Toledo, by the way, the painter's hometown. El Greco created this painting about a hundred years after the spectacular discovery of the Laocoön. Times had changed, though. Renaissance ideas no longer reached the artist. In art history this period is known as Mannerism, a movement the Renaissance intentionally left in its wake, albeit without knowing what might become of it. Its adherents sowed the seeds for the Baroque age. Their primary objective, however, was to destroy the formalism the Renaissance had engendered, those grand, grandiose, harmonious guiding principles.

Nothing at all appears to connect father and sons in this hideous image, not even at the moment of their gruesome death, which in El Greco's rendering comes across less as gruesome than grotesque. Or perhaps it represents a moment of salvation. Flayed figures set before a somber background, yet the effect of the scene is more bizarre than it is heavy, as if it depicted a calisthenics routine that had got out of hand. One son is already dead, as is the other, presumably, and Laocoön simply lies there. The figures to the right, the monsignor explains, are probably the god and goddess Apollo and Artemis observing the scene. There may, in fact, be another figure; as you can see, there's a third head and extra leg here. Who was that supposed to be? A ghastly picture, the monsignor concludes in disgust. The end. Chaos and uncertainty are all that remain. A counterimage, he says. And it had to be Laocoön.

The monsignor again gently cocks his head, and again, with an investigator's curiosity in his eyes, traces the inside edge of the frame. He again positions the letter opener, which has remained in his hand throughout, and this time, the sound of tearing paper is quieter. The monsignor appears to take some pleasure in cutting the picture out of the frame.

The monsignor briefly looks up at K. before removing El Greco's Laocoön. At first glance, what appears beneath looks like a scrap of paper. Upon closer examination, however, its contours are distinctive, six more or less pointed edges, almost uniform in size, the piece clearly not cut, but torn from another page.

It's a piece of old paper, the monsignor says. Very old, it would appear. Perhaps a document, a fragment of a historic document. It looks like a star, doesn't it? the monsignor asks. Like a Star of David. Wouldn't you agree?

That, says K., must be the old Torah fragment from the synagogue in Prague. Did you know that the Star of David was used as a talisman to ward off danger in the Middle Ages? I didn't, says K., until Pollak told me.

Of all things, the monsignor responds. From his response, it is impossible to infer whether the information is new to him. He places the two reproductions back on top of the timeworn document, then stands up to collect the three letters and return the picture frame to its brown wrapping. At the door, he gestures for K. to exit first.

Had Pollak come here, the monsignor says in the open doorway, light falling into the small chamber from the corridor, we could have told him that the arm is, in fact, the real one. Ernesto Vergara Caffarelli has been working since the year before last on a new reconstruction of the Laocoön group. His initial findings are known, though not yet published. Caffarelli has determined why the marble of the arm presents differently than the surface of the statue. It can be traced back to the fact that the statue group and broken arm were stored under different conditions for a very long time, then cleaned and treated differently. The arm is simply not as well preserved. The surface of the sculpture, meanwhile, also changed every time it was used to make molds for casting. Caffarelli conducted studies of human movement and

consulted anatomical muscle analyses to assess the position-
ing of the arm. The reason the arm appears too small can be
attributed to a desired foreshortening effect. It's unlikely an
old copy ever existed.

THE TRAIN departs the Roma Tiburtina station on Monday, October 18, at 2:05 p.m. Jammed into its eighteen boxcars are one thousand twenty-two people ranging in age from one day to ninety-nine years old. Of them, sixteen will survive. One thousand two hundred ninety-five individuals are detained during the raid and transferred to the Collegio Militare on Via Lingara on the banks of the Tiber. Several are released, most of these people so-called half-Jews or those in so-called mixed marriages. Another attempt was purportedly made to rescue Ludwig Pollak at this juncture, although no evidence exists to substantiate the claim. According to another account, Cardinal Eugène Tisserant appealed directly to Heinrich Himmler on Pollak's behalf, and Himmler directed the train to stop in Varese. There is no proof this happened, either. All traces of Ludwig Pollak and his family are lost after their abduction. The train ride lasts until Friday, October 23. Josef Mengele stands on the ramp at Auschwitz and selects one hundred eighty-four as fit for work. The others are sent by truck to nearby Birkenau and into the gas chambers.

COMM. DR. LUDWIG POLLAK, residing at Piazza dei Santi Apostoli n. 88, was apprehended and deported last Saturday, the 16th of this month, along with his wife and two children (4 persons, all infirm), on the basis of his affiliation with the Jewish race, as was communicated to me at the Collegium Militare. As this directive amounted to a general order that is at once subject to review and reversal, the undersigned implores the highest German authorities to make an exception in the case of Comm. Pollak and family, the gentleman having resided in Rome for nearly fifty years and never claimed membership in any political group. He has devoted himself to the antiquarian profession in the most honest and honorable manner, thus advancing the various branches of archaeology with great success. His name and academic reputation are closely associated with his renowned publications; many years ago, he was even named an honorary member of the German Archaeological Institute. He has nurtured strong ties to the director and representatives of the National Roman Museum and earned the esteem of the Vatican Museums by donating two important finds procured at his own expense:

1) *an arm that very likely belongs to the famous Laocoön group, and which was recently reattached to the group in the Roman College plaster cast collection;*

2) *a Christian funerary glass stolen seventy years earlier from the Vatican Library, which he discovered, recognized, and returned to Pope Pius X, who conferred upon him the gold medal for exceptional deeds.*

It therefore stands to reason that the undersigned, who is informed of these facts and has been bound by friendship to Pollak for more than forty years, would take an active interest in his case and submit the urgent request that he and the three members of his family be returned to their home.

Prof. Bartolomeo Nogara
22.X.1943

ACKNOWLEDGMENTS

I first learned of Ludwig Pollak (1868–1943) in Helga Schütz's novel *Sepia*, published in 2012. The story made a lasting impression, from which my own book would emerge, thanks to Andrea Wildgruber and Susanne Schüssler. I am grateful to Orietta Rossini and the Museo Barracco in Rome for access to the Ludwig Pollak archive, which includes his personal library. Thanks to Arnold Nesselrath for the leads and warnings that emerged in our many conversations. Thanks also to Margarete Guldan, Eva Ehninger, Isabella von Treskow, Pauline Schimmelpenninck, Christiane Nesselrath, Boris Hars-Tschachotin, Steffen Gommel, Susanne Muth, Enrico Brissa, and Diethelm Kaiser for his meticulous help in the genesis of this text. I am indebted to Claudia Valeri and Giandomenico Spinola at the Vatican Museums, Valeria Capobianco and Ortwin Dalli at the German Archaeological Institute in Rome, and the staff at both the Goethe and Schiller Archive in Weimar and the archive at the Federal Foreign Office in Berlin. Warm thanks to my American publisher, Michael Z. Wise at New Vessel Press, as well as Elisabeth Lauffer, who met the challenge of translating this text with astonishing ease and intuition.

Considerable portions of Ludwig Pollak's biographical memories in this work of fiction are based on his papers and diaries archived at the Museo Barracco in Rome; on the transcription of his diaries annotated by Margarete Guldan (*Die Tagebücher von Ludwig Pollak. Kennerschaft und Kunsthandel in Rom. 1893–1934* [Vienna, 1988]); on Margarete Guldan's *Römische Memoiren: Künstler, Kunstliebhaber und Gelehrte 1893–1943* (Rome, 1994); and on unpublished letters housed in various archives, most notably the archive at the German Archaeological Institute in Rome and the Goethe and Schiller Archive in Weimar. The letters on pages 122 to 126 are quoted from Margarete Guldan's *Die Tagebücher von Ludwig Pollak. Kennerschaft und Kunsthandel in Rom. 1893–1934*, and the letter on pages 137 and 138, originally written in Italian and translated into German by the author, is quoted from *Ludwig Pollak: Archaeologist and Art Dealer, Prague 1868–Auschwitz 1943*, edited by Orietta Rossini (Rome, 2019).

Reports on the number of Roman Jews deported (1,022 or 1,035) and selected at Auschwitz (184 or 196) vary between sources.

Hans von Trotha, January 2021

HANS VON TROTHA is a German historian, novelist, and journalist who spent ten years as editorial director of the Nicolai publishing house in Berlin, where he now lives.

ELISABETH LAUFFER has translated *Animal Internet* by Alexander Pschera and *The Piano Student* by Lea Singer for New Vessel Press.

DISTANT FATHERS
BY MARINA JARRE

This singular autobiography unfurls from the author's native Latvia during the 1920s and '30s and expands southward to the Italian countryside. In distinctive writing as poetic as it is precise, Marina Jarre depicts an exceptionally multinational and complicated family. This memoir probes questions of time, language, womanhood, belonging and estrangement, while asking what homeland can be for those who have none, or many more than one.

NEAPOLITAN CHRONICLES
BY ANNA MARIA ORTESE

A classic of European literature, this superb collection of fiction and reportage is set in Italy's most vibrant and turbulent metropolis—Naples—in the immediate aftermath of World War Two. These writings helped inspire Elena Ferrante's best-selling novels and she has expressed deep admiration for Ortese.

UNTRACEABLE
BY SERGEI LEBEDEV

An extraordinary Russian novel about poisons of all kinds: physical, moral and political. Professor Kalitin is a ruthless, narcissistic chemist who has developed an untraceable lethal poison called Neophyte while working in a secret city on an island in the Russian far east. When the Soviet Union collapses, he defects to the West in a riveting tale through which Lebedev probes the ethical responsibilities of scientists providing modern tyrants with ever newer instruments of retribution and control.

What's Left of the Night
by Ersi Sotiropoulos

Constantine Cavafy arrives in Paris in 1897 on a trip that will deeply shape his future and push him toward his poetic inclination. With this lyrical novel, tinged with an hallucinatory eroticism that unfolds over three unforgettable days, celebrated Greek author Ersi Sotiropoulos depicts Cavafy in the midst of a journey of self-discovery across a continent on the brink of massive change. A stunning portrait of a budding author—before he became C.P. Cavafy, one of the 20th century's greatest poets—that illuminates the complex relationship of art, life, and the erotic desires that trigger creativity.

The 6:41 to Paris
by Jean-Philippe Blondel

Cécile, a stylish 47-year-old, has spent the weekend visiting her parents outside Paris. By Monday morning, she's exhausted. These trips back home are stressful and she settles into a train compartment with an empty seat beside her. But it's soon occupied by a man she recognizes as Philippe Leduc, with whom she had a passionate affair that ended in her brutal humiliation 30 years ago. In the fraught hour and a half that ensues, Cécile and Philippe hurtle towards the French capital in a psychological thriller about the pain and promise of past romance.

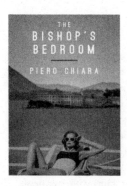

The Bishop's Bedroom
by Piero Chiara

World War Two has just come to an end and there's a yearning for renewal. A man in his thirties is sailing on Lake Maggiore in northern Italy, hoping to put off the inevitable return to work. Dropping anchor in a small, fashionable port, he meets the enigmatic owner of a nearby villa. The two form an uneasy bond, recognizing in each other a shared taste for idling and erotic adventure. A sultry, stylish psychological thriller executed with supreme literary finesse.

THE EYE
BY PHILIPPE COSTAMAGNA

It's a rare and secret profession, comprising a few dozen people around the world equipped with a mysterious mixture of knowledge and innate sensibility. Summoned to Swiss bank vaults, Fifth Avenue apartments, and Tokyo storerooms, they are entrusted by collectors, dealers, and museums to decide if a coveted picture is real or fake and to determine if it was painted by Leonardo da Vinci or Raphael. *The Eye* lifts the veil on the rarified world of connoisseurs devoted to the authentication and discovery of Old Master artworks.

THE ANIMAL GAZER
BY EDGARDO FRANZOSINI

A hypnotic novel inspired by the strange and fascinating life of sculptor Rembrandt Bugatti, brother of the fabled automaker. Bugatti obsessively observes and sculpts the baboons, giraffes, and panthers in European zoos, finding empathy with their plight and identifying with their life in captivity. Rembrandt Bugatti's work, now being rediscovered, is displayed in major art museums around the world and routinely fetches large sums at auction. Edgardo Franzosini recreates the young artist's life with intense lyricism, passion, and sensitivity.

ALLMEN AND THE DRAGONFLIES
BY MARTIN SUTER

Johann Friedrich von Allmen has exhausted his family fortune by living in Old World grandeur despite present-day financial constraints. Forced to downscale, Allmen inhabits the garden house of his former Zurich estate, attended by his Guatemalan butler, Carlos. This is the first of a series of humorous, fast-paced detective novels devoted to a memorable gentleman thief. A thrilling art heist escapade infused with European high culture and luxury that doesn't shy away from the darker side of human nature.

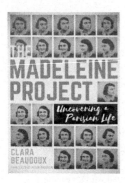

THE MADELEINE PROJECT
BY CLARA BEAUDOUX

A young woman moves into a Paris apartment and discovers a storage room filled with the belongings of the previous owner, a certain Madeleine who died in her late nineties, and whose treasured possessions nobody seems to want. In an audacious act of journalism driven by personal curiosity and humane tenderness, Clara Beaudoux embarks on *The Madeleine Project*, documenting what she finds on Twitter with text and photographs, introducing the world to an unsung 20th century figure.

ADUA
BY IGIABA SCEGO

Adua, an immigrant from Somalia to Italy, has lived in Rome for nearly forty years. She came seeking freedom from a strict father and an oppressive regime, but her dreams of film stardom ended in shame. Now that the civil war in Somalia is over, her homeland calls her. She must decide whether to return and reclaim her inheritance, but also how to take charge of her own story and build a future.

IF VENICE DIES
BY SALVATORE SETTIS

Internationally renowned art historian Salvatore Settis ignites a new debate about the Pearl of the Adriatic and cultural patrimony at large. In this fiery blend of history and cultural analysis, Settis argues that "hit-and-run" visitors are turning Venice and other landmark urban settings into shopping malls and theme parks. This is a passionate plea to secure the soul of Venice, written with consummate authority, wide-ranging erudition and élan.

THE MADONNA OF NOTRE DAME
BY ALEXIS RAGOUGNEAU

Fifty thousand people jam into Notre Dame
Cathedral to celebrate the Feast of the
Assumption. The next morning, a beautiful
young woman clothed in white kneels at prayer
in a cathedral side chapel. But when someone
accidentally bumps against her, her body collapses.
She has been murdered. This thrilling novel
illuminates shadowy corners of the world's most
famous cathedral, shedding light on good and evil
with suspense, compassion and wry humor.

THE LAST WEYNFELDT
BY MARTIN SUTER

Adrian Weynfeldt is an art expert in an
international auction house, a bachelor in his
mid-fifties living in a grand Zurich apartment filled
with costly paintings and antiques. Always correct
and well-mannered, he's given up on love until
one night—entirely out of character for him—
Weynfeldt decides to take home a ravishing but
unaccountable young woman and gets embroiled in
an art forgery scheme that threatens his buttoned
up existence. This refined page-turner moves behind elegant bourgeois facades
into darker recesses of the heart.

MOVING THE PALACE
BY CHARIF MAJDALANI

A young Lebanese adventurer explores the wilds of
Africa, encountering an eccentric English colonel
in Sudan and enlisting in his service. In this lush
chronicle of far-flung adventure, the military recruit
crosses paths with a compatriot who has dismantled
a sumptuous palace and is transporting it across the
continent on a camel caravan. This is a captivating
modern-day Odyssey in the tradition of Bruce
Chatwin and Paul Theroux.

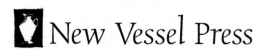

New Vessel Press

*To purchase these titles and for more information
please visit newvesselpress.com.*